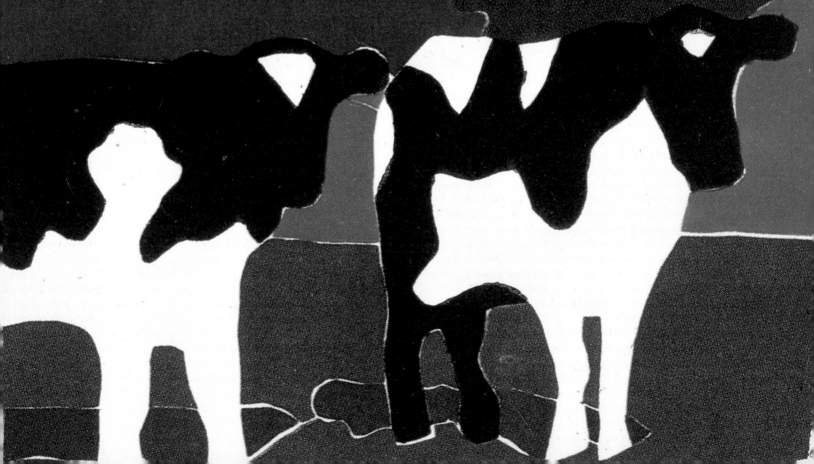

Wholly Cow!

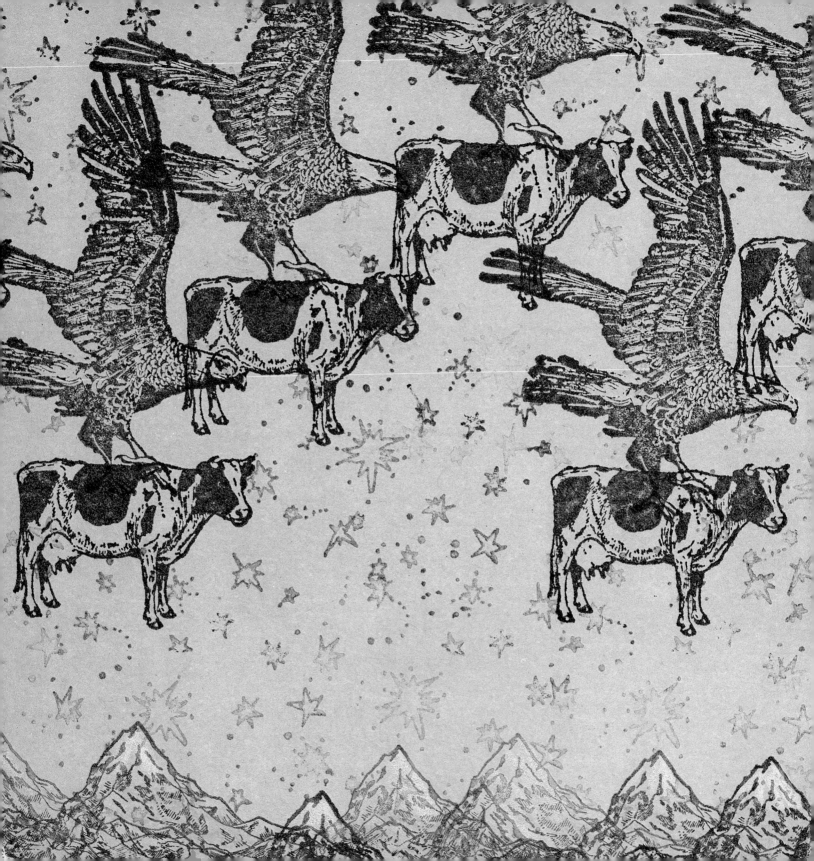

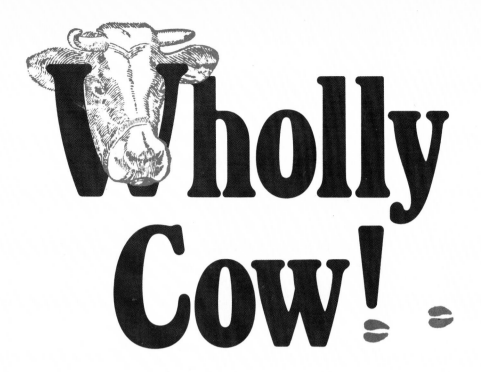

Wholly Cow!

By Emily Margolin Gwathmey

Photographs by
Niki Berg

ABBEVILLE PRESS · PUBLISHERS · NEW YORK

Editor: Walton Rawls
Designer: Julie Rauer
Production Supervisor: Hope Koturo

Library of Congress Cataloging-in-Publication Data

Gwathmey, Emily Margolin.
 Wholly cow! / by Emily Margolin Gwathmey ; photographs by
Niki Berg.
 p. cm.
 ISBN 0-89659-816-0
 1. Cows—Miscellanea. 2. Cows—Pictorial works. I. Berg, Niki.
II. Title.
SF197.4.G85 1988
636.2—dc19 88-957
 CIP

Contents

Has anyone sung the song of the patient,
calf-bearing, milk-flowing, cud-chewing,
tail-switching cow?

FRANK LLOYD WRIGHT

Preface

From the beginnings of civilization, humans have
been dependent on cows. Dominant both on earth
and within the imagination, the cow is so richly symbolic
that for the past 8,000 years artists have shaped and
reshaped her in materials ranging from stone to lace
to verse.

The cow has been the subject of Greek myths, pop art
paintings, poets' whimsy, children's wonder, and a culture's
worship. She sports a splotched, multicolored coat adorned
with horns and bells, posing perfectly for a picture in any
landscape. She has been called Elsie, Bossie, Clarabelle,
Flossie, and Bess.

Could it finally be time for the cows to come home? Let's
hear it for the lovely ladies. Here's to raising cow-consciousness!

LES ANIMAUX DE LA FERME

VACHE FLAMANDE

VACHE COMTOISE

VACHE PICARDE

VACHE DE MONTBÉLIARD

VACHE DE JERSEY

VACHE DE SALERS

VACHE GASCONNE

VACHE GARONNAISE

VACHE VENDÉENNE

VACHE BAZADAISE

VACHE BRETONNE

VACHE SUISSE TACHETÉE OU BERNOISE

VACHE SUISSE BRUNE OU SCHWITZ

VACHE ANGUS OU SANS CORNES

VACHE HOLLANDAISE

Paris, E. RAPP, imprimeur.

LES FILS D'ÉMILE DEYROLLE, éditeurs, 46, rue du Bac, Paris.

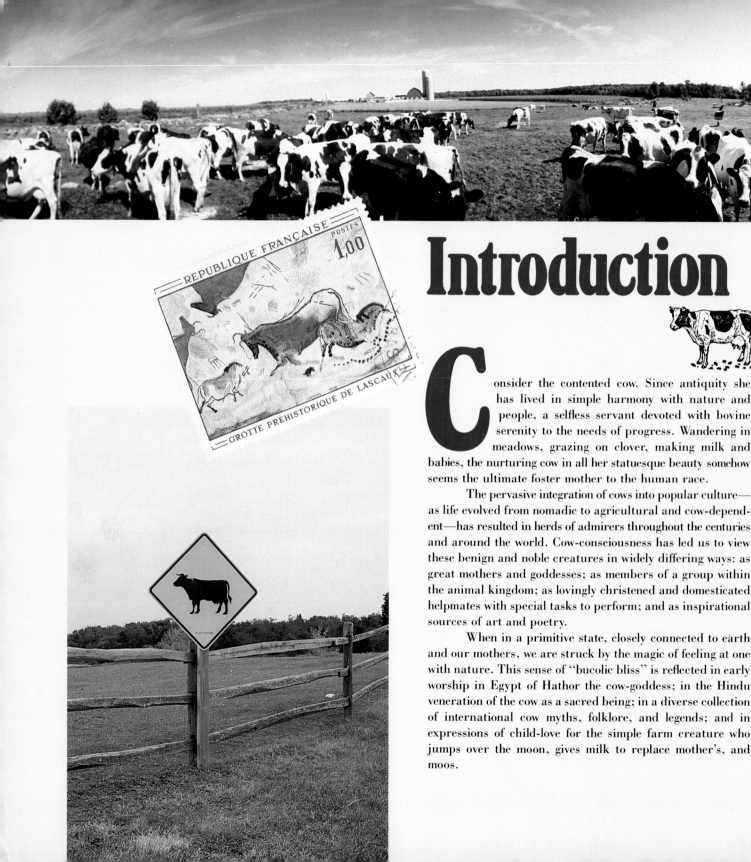

Introduction

Consider the contented cow. Since antiquity she has lived in simple harmony with nature and people, a selfless servant devoted with bovine serenity to the needs of progress. Wandering in meadows, grazing on clover, making milk and babies, the nurturing cow in all her statuesque beauty somehow seems the ultimate foster mother to the human race.

The pervasive integration of cows into popular culture—as life evolved from nomadic to agricultural and cow-dependent—has resulted in herds of admirers throughout the centuries and around the world. Cow-consciousness has led us to view these benign and noble creatures in widely differing ways: as great mothers and goddesses; as members of a group within the animal kingdom; as lovingly christened and domesticated helpmates with special tasks to perform; and as inspirational sources of art and poetry.

When in a primitive state, closely connected to earth and our mothers, we are struck by the magic of feeling at one with nature. This sense of "bucolic bliss" is reflected in early worship in Egypt of Hathor the cow-goddess; in the Hindu veneration of the cow as a sacred being; in a diverse collection of international cow myths, folklore, and legends; and in expressions of child-love for the simple farm creature who jumps over the moon, gives milk to replace mother's, and moos.

REPUBLIQUE FRANCAISE POSTES 1,00

GROTTE PREHISTORIQUE DE LASCAUX

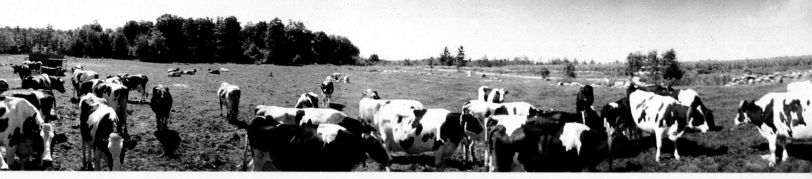

"Holsteins at Pasture," photograph 1981 © Gus Foster

As the feeling of closeness to the cosmos changes, we become part of an earth-anchored family of man. Now we perceive that cows are part of a herd known as *genus bos*. Images abound of cow communities down on the farm and home on the range, from prehistoric paintings in the caves of Lascaux to twentieth-century government murals in Washington, D.C.

Becoming more highly organized, we strive to detach ourselves from the group. To attain a feeling of separateness and self-importance, we join the working world as productive members of society. Now comes the chance to distinguish ourselves as unique—to become stars. This state of evolution parallels our perceptions of cows and their idiosyncratic characteristics. Cows are humanized and named. Occasionally one may even rise to stardom, as in the case of Elsie, the Borden Company's heroic spokescow.

Adjusting our focus from the finite to the infinite, we slowly let go of our attachment to things. We become more meditative and appreciative of the transcendent, as expressed through art, poetry, and music. This heightened sensibility is found reflected in cow motifs, fancifully transformed into myriad objet d'art such as pins, porcelain, masks, mugs, sweaters, and stamps, as well as in serious works of cow art by world-famous artists through the ages.

Eternally dependable, yet oddly neglected, often maligned and even taken for granted, the whole cow is here at last given a sacred and secular tribute, in a treasury of folk art, literature, sculpture, painting, ceramic, song, photography, and advertising that celebrates the 8,000-year interdependence and mutual affection between bovine and homo sapiens.

9

Common Cows: Genus Bos

Cow, drawing © CVO Designs, Vermont

At first she was a wild creature, part of a migrating herd of bovine mammals known as aurochs (*bos primigenus*). These gigantic beasts roamed the plains and forests of Asia, Africa, and Europe. Now extinct (the last aurochs cow died in Poland in 1627), aurochs spanned six feet at the shoulder, sported long hair, lyre-shaped horns, came in black, brown, spotted, and roan, and were exceedingly fierce in their habit of standing up to any threat. A smaller species, the Celtic shorthorn (*bos longiforms*), with elegant, elongated faces and shorter horns, also figures strongly in the modern cow's ancestry, as does the hardy, humpbacked African zebu breed (*bos indicus*).

As our ancient ancestors began to follow these migrating communities of wild cows around, they grew increasingly dependent on them as a source of food and strength. Eventually, mankind took the lead and cows became the domesticated followers. From the beginning, great wealth came from having more cows than anyone else. To this day cows bring status among the pastoral Tutsi and Masai of Africa, the gauchos of Argentina, and the cowboys of the American West. In fact, "impecunious," or lack of wealth, literally means "without cows," from *pecus*, the Latin for a herd of cows.

Here, then, are the many aspects of cows as a breed apart, forming communities worldwide in the service of humankind.

10

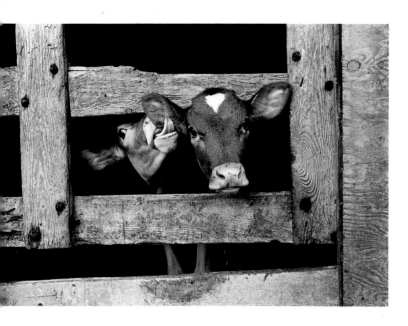

"Passion," photograph
© B. A. King, Massachusetts

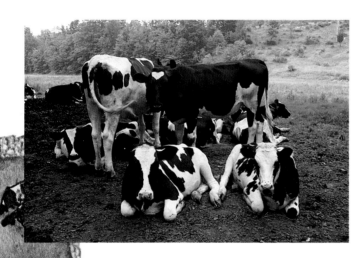

Stonewall, painting by Alexander
Hollweg, © Artists Postcards
1978, New York City

To Her!

BY FRANK LLOYD WRIGHT

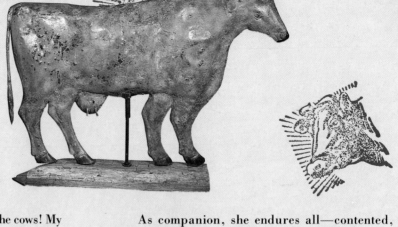

COW! What a word! And, cow-bell! The cows! My boy, the cows! Always—"the cows!"

The Valley cows were red—Durhams—until Uncle James later got a black-and-white Holstein bull, envy of all the township. And so the herd, from year to year, grew to black and white. In three years the cattle in the Valley all changed from red to black and white.

Why is any cow, red, black or white, always in just the right place for a picture in any landscape? Like a cypress tree in Italy, she is never wrongly placed. Her outlines quiet down so well into whatever contours surround her. A group of her in the landscape is enchantment.

Has anyone sung the song of the patient, calf-bearing, milk-flowing, cud-chewing, tail-switching cow? Slow-moving, with the fragrant breath and beautiful eyes, the well-behaved, necessary cow, who always seems to occupy the choicest ground anywhere around?

She is the dairy farm, the wealth of states, the health of nations.

How many trusties and lusties besides her lawful calf have pulled away at her teats these thousands of years until the stream flowing from them would float fleets of battleships, drown all the armies the world has ever seen.

How the cow has multiplied the man!

And yet, so battened upon, she is calm, faithful, fruitful.

As companion, she endures all—contented, even indifferent.

But the Minnesingers down all the ages have given small place to the cow in poetry or song.

She is just a Cow.

Yet, to go through the herd lying on the grass, as the dew falls all quietly chewing their cud in peace together, is to find a sweetness of the breath as it rises, a freshness of Earth itself that revives something essential to life lying deep in the instincts of the human race.

Is the cow now mother to the man to such an extent that his "instinct" begins to be aware of her in this exhalation from her nostrils?

And the dung that goes from her to the fields by way of sweating youths and men saturated, struggling in the heavy odor and texture of her leavings! This indispensable wealth that goes to bring back the jaded soil to a greenness of the hills, bring fertility to life itself—for man!

Yes, where her tribe flourishes there the earth is green, the fields fertile. Man in well-being and abundance.

She is Hosanna to the Lord! For where she is, "at destruction and famine man laughs," as he salts her, fodders her, beds her, breeds her and milks her. Thus tended she contentedly eats her way from calfhood clear through to the digestive tract of humanity—her destiny. Her humble last farewell to man—the shoes upon his feet!

(from *An Autobiography*)

"Tinkerbell," photograph
© B. A. King, Massachusetts

Holstein Flossie with her pretty
plaid bow stands guard over
some other examples of bovine
beauty: a delicate 1930s French
bisque cow, a paper-thin cello-
phane cow from America and two
English metal cows made in the
1940s.

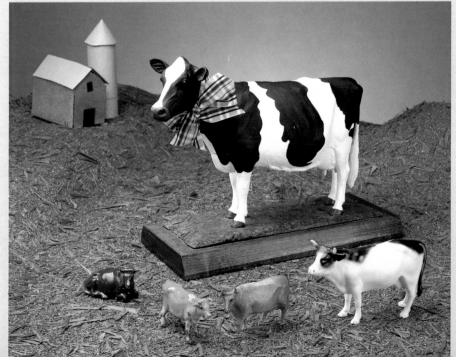

Dear Ms. Gwathmey:

I'm intrigued about your query in the *N.Y. Times Book Review*—had to read it twice to be sure you meant a book about cows. I imagined a book the size of the OED, then realized it has to be bigger than that. Our little library has a whole section devoted to books about cows.

I'm not sure if you have tremendous courage or tremendous innocence or both. You'll need the courage just for the hundreds of letters you'll receive.

I grew up with Herefords. That's practically all there were around here until about 20 years ago when they started getting all these exotic breeds. Long Horns are popular now, not just for the fun of it but also because they have smaller calfs, so they breed cows with a Long Horn bull for the cow's first pregnancy.

The above paragraph is not written as a cowman would speak, but in layman's terms. You will need a whole new vocabulary for talking about cows. It's like talking about horses, you know, with all the dams and gets, and such.

The one cow that stands out in my mind was a Jersey named Lois. She was just for milking, of course. Some ranchers just milked their Herefords, but my mother thought a Jersey gave more and higher quality milk. During World War II when milk as well as everything

Drawing by W. Steig, © 1984 *The New Yorker*

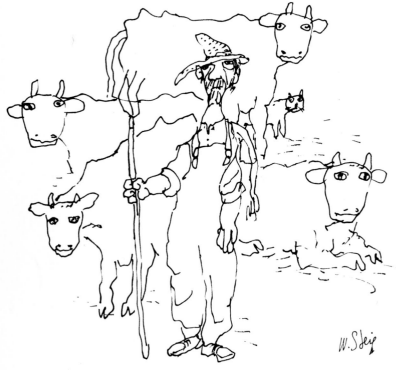

W. Steig

Kine

Farmer, blacksmith, and folk artist Adelard Coté (1899–1974) of Biddeford, Maine, produced hundreds of carvings, including this charming view of a milker and three cows.

else was hard to get, she brought Lois from the ranch to town so we could have milk—"we" being my five brothers and sisters and me. She had a man to come morning and evening to milk, but when he didn't show up, which was fairly frequently, she had to milk Lois herself. If you're picturing a country woman in a bonnet change it to a lady in a Lilli Daché hat, coiffed and manicured. Then one time when my mother was out of town, my aunt who was registrar and professor of English at the college here had to milk Lois. Well, cows are very particular as you will find out, and Lois didn't like my aunt's methods, so she kicked the bucket and she kicked my aunt and for a whole week we only got about a half a cup of milk a day. But my aunt kept Lois from going dry and that was the important thing.

All the reminiscences, recollections, photos, and paintings you may get won't tell you as much about cows as living with them awhile. They are as varied as human beings and on the whole a lot more cantankerous. The person who penned the immortal words ". . . and the cow jumped over the moon" knew a lot about cows.

<div style="text-align:center">

Sincerely,

Emilie B. Severin
Alpine, Texas
</div>

Genus Bos, painting by Claus Hoie, © Artists Postcards 1977 New York City

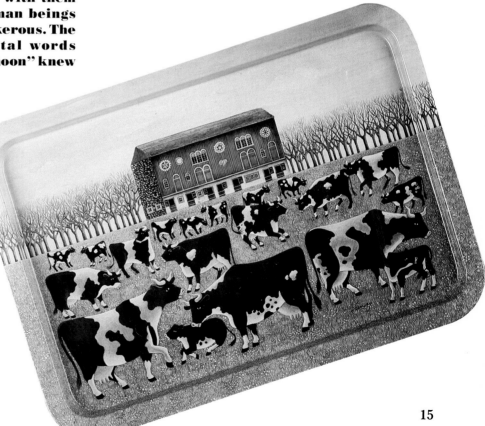

15

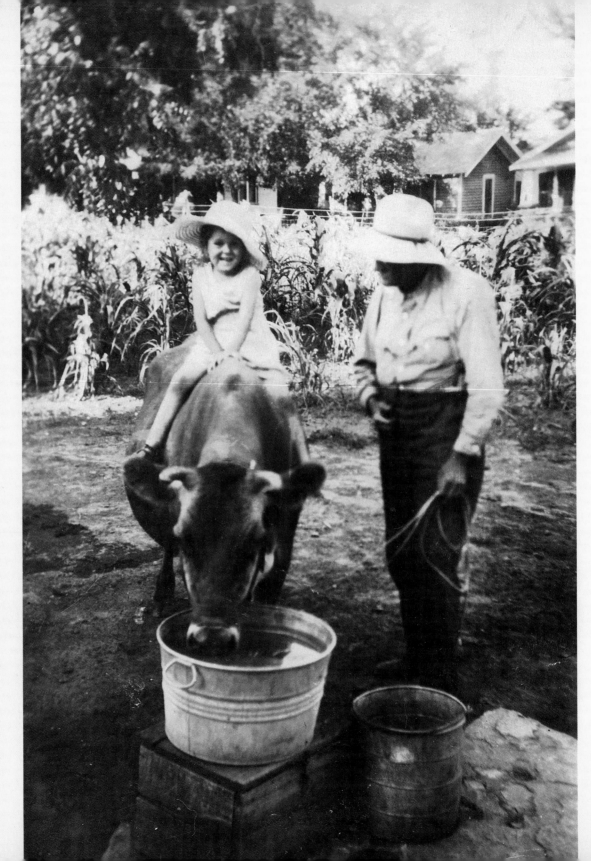

At age three, Mary Louise Kitsen rides Clara the Cow. 1933, Winfield, Kansas

(opposite) Mary Louise Kitsen with Clara the Cow, Danny the horse, and Great-Uncle Jess Christy, 1935, Winfield, Kansas

16

Dear Ms. Gwathmey:

When I was a little girl, I knew a secret. Cows were more fun . . . and more comfortable to ride.

Actually I wasn't a farm girl. I lived in the center of Plainville, Connecticut. And loved it. But from the end of June until the end of August I visited by great-grandmother, Lillie Shepherd Wright, on her small farm in Winfield, Kansas. Grandma had been widowed young and her stepbrother, Jess Christy, came up from Texas and took care of the farm. Uncle Jess was a huge, happy man who taught little girls all sorts of things . . . such as riding Clara the Cow! Clara was gentle. She was easy to sit on. She remained good-natured even when Uncle Jess made a saddle so I could ride her even more easily.

Clara and I smooched a lot! We looked into each other's eyes. We were friends. It was a relationship I thought would never come to an end.

However, the summer came when I arrived in Kansas only to learn some upsetting news. Uncle Jess took me to the chili joint we both loved, and while we were eating Uncle Jess told me I was too heavy to ride Clara anymore. I cried all the way home.

Uncle Jess had a horse and a saddle ready. I loved Danny but I would have rather continued riding Clara. Poor Clara. I hugged her neck and told her over and over why I wasn't riding her. Grandma and Uncle Jess assured me that Clara didn't understand me. I believed them too. Because every single time Clara saw me on Danny, she let out a moo that sounded more like a cyclone warning than the cyclone warning sounded.

All these years later, I still remember Clara with much love . . . and a bittersweet sadness—happiness.

Mary Louise Kitsen
Plantsville, Connecticut

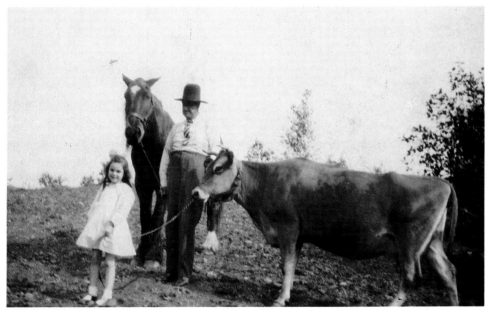

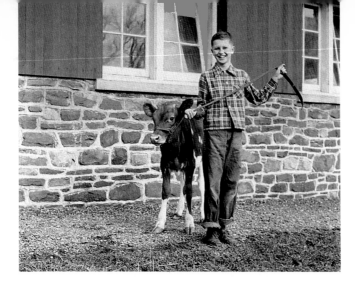

Photograph of young Roger Smith with a Guernsey calf was taken by his father Clifford W. Smith in 1953, at Wychmere Farm, Ontario, New York

Dear Ms. Gwathmey:

I have been greatly taken by your plan to bring out a book about cows. In my regard for cows, going back to early boyhood, I am almost a Hindu! It is comforting to know that someone evidently also has a warm place in her heart for them. I can't help wondering how you conceived such an interest in them.

Strictly for whatever amusement you might find in it, I am sending you a little essay called "The Cow" that I wrote when I was sixteen (please bear in mind that that was all I was!) and that won me a prize consisting of a munificent ten dollars worth of books (this was in 1927) of my own selection, presented by the principal of the high school—Lincoln School in New York City. Printed in the graduating class yearbook, it was my first published work and so I suppose could be said to have begun my life as a writer.

Sincerely,
Charlton Ogburn
Beaufort, South Carolina

The Cow

BY CHARLTON OGBURN, JR.

You may love the pup-dog for his good humor, admire the fish for his face, feel like a brother to the noble horse, but no bird, beast or reptile can compare with the cow. Familiarity with the dog breeds contempt. A fish you possess as so much. A horse labors under you. You understand these animals, therefore you feel yourself superior to them. But a cow! Anyone who can stand in front of a cow and not be completely humbled, cowed in fact, has no heart, soul, or conscience. The animal knows you are in every way her inferior and you know she knows. However, a cow is not haughty. She is pitying. You look into her eyes and she reads your troubles, sighs, and stops chewing her cud for a moment, but only for a moment. A cow without her cud is as a machine without its wheels. It is of a vital necessity to her. It's her personality. The instant mastication is arrested and a sense of impending disaster is created; you quake before her. Then the jaws are again set in motion and once more her motherly feeling towards you reigns supreme. A cud is a mysterious thing. What is it? No one knows. No one has ever seen one, and yet it is a familiar word in all our vocabularies. Cud, cud, cud. Repeat it to yourself once or twice. Strange sounding, isn't it? And so vital, too! It is chewed at all hours of the day and night. The only time when the chewing process is not going on is when the cow is eating, drinking or asleep. Also in moments of intense excitement when the soul of the cow comes back to earth having possibly been off in the distant past when the race was young and ruled the earth. Then all faculties are concentrated on immediate action.

When one gazes into the deep wells of softness in her eyes one realizes that here is no ordinary creature. One knows that here is a being who has suffered, but who long ago became resigned to her fate.

Who has ever seen a cow and not wondered at the strange difference between body and soul? Perhaps long ago the cow looked into the garden of the Lord High Muck-a-

muck of ancient magicians, not realizing to whom it belonged, and as a punishment his Highness took away her deer-like body, which she must formerly have possessed, and hocus-pocused her into the body which she now wears. So logical is this that one might dare to venture that it is on this every cow meditates the whole day long. Her body is completely lacking in any form of beauty or symmetry. Her two sides are often not even congruent, and her gait certainly shows no grace. Her hind legs seem to be quite innocent of joints. A cow in the act of lying down is the most heart-rending sight to be found in the world of nature. At first she looks at her intended bed with a gaze that would convulse a stone idol with tears, then she sinks to her knees (front knees only, please note), and then slowly draws her hind legs under her and sinks to the earth. Two seconds after her destination is reached the surrounding shrubbery is bent by a titanic sigh. Poor creature! Well may she look supplicatingly at the earth, and sigh when it is reached! How easily she used to be able to perform this act, that is, before his Highness, the Ancient Magician, had performed his stuff.

Cows are, on the whole, gentle, calm, and well bred. (It seems to me I have heard this phrase applied to Poe.) But, even to their strong minds, temptation is often irresistible. Temptation is usually in the form of a garden. Although it may have a ten-foot wall and be surrounded by a moat, it is not impregnable to the attacks of the average bovine. I don't believe a whole army of machine-gunners could keep a cow out of a garden if she had the faintest inclination to force an entrance.

It is indeed a fortunate thing for the dairymen that cows are usually satisfied with captivity. If this were not so, certainly fence-making would be quite a task on a dairy farm. Once one of these peaceful animals decides to go on a spree, no fence in the country could hold her back. She'll go over it, under it, or through it, but she'll get on the other side.

Cows are just as individual as humans, and almost as much so as chickens. Of course everyone will admit that no two cows are marked exactly alike. Most people will agree that the faces of different cows are entirely unlike, but only those who have been on speaking acquaintance with them know how unalike their characters are. Some are utterly dumb, some shrewd, some mean, and a few confiding. Cows are not often fed from the hand because of their absent-minded habit of taking in the hand also.

As far as I can remember, I have seen only about four cows who know their names. One of these was a special pet of mine. "Wong-Bok" was her name. (She was named after a brand of cabbage) and she was the most un-cowy cow I've ever seen, being the only one I've ever heard of that would allow one to get on her back. The poor beast was eventually eaten. I've often wondered if I unconsciously helped.

Probably everyone has wondered that if all the humans were to disappear from the earth what animals would rule in their stead. Monkeys would I'm sure, although cows would be better. But unless the cow's nature changes, she will never be more than she is. She is unambitious and contented, self-satisfied, unobtrusive, and patient. Her air of resigned patience is so strong that one cannot help wondering what she is waiting for.

(from *Lincolnian*, 1928)

Wychmere Farm, 1939, photograph by Clifford W. Smith

Dear Ms. Gwathmey:

Cows have always fascinated me. When I was a boy growing up in the shadow of the Great Smoky Mountains, my father had a dairy farm and it was my lot to help milk the 40 cows by hand. I can still feel the cold darkness when I had to rise and make a fire in the fireplace at 4 A.M., then shivering, jump back under my mother's soft and warm featherbed until the fire had heated the chilly room.

Then, carrying a lantern, I made my reluctant way down to the barn, huddled up against each cow to keep warm while I milked. Sometimes I would get so close, the cow stepped on my foot—which brought a yell from me and a reprimand from my father nearby.

Once when driving the herd down a lane, I thought it would be nice to ride one of the cows. So I jumped up on one broad back but soon found I could not stay there, fell to the ground and the whole herd ran over—or by— me. It was a wonder I was not crushed.

But all this was fun. While watching the cows as they foraged in the green meadow, I read books—and that was the beginning of my literary life. Best wishes with your book,

North Callahan

**North Callahan
(Professor Emeritus of History,
New York University)
Chattanooga, Tennessee**

"Milking Time," photograph by Nancy Ford Cones

In 1905 the Eastman Kodak Company held a photographic competition that drew 28,000 entries. First prize went to Edward Steichen; the third-prize winner was Alfred Stieglitz. Second prize was awarded to a young farmwife from Loveland, Ohio, Nancy Ford Cones. During her long life as a photographer (she died in 1962 at age ninety-three), Cones documented the life of friends and relatives on the family farm. Here, daughter Margaret waits while a neighbor does the necessary. (Courtesy of the Nancy Ford Cones Estate)

Cow Society

BY VANCE PACKARD

© Artlie 1982

The cow—which has been called the Foster Mother of the Human Race—is a fascinating animal. Studies have shown she is so dumb she doesn't know her own name. Yet any farmer will tell you she is smart enough to get her way, can be exasperatingly stubborn, coy, placid or irritable, and adores being pampered.

Dr. W. E. Petersen, Professor of Dairy Husbandry at the University of Minnesota, has spent 26 years trying to understand the cow. In the pasture a herd of cows appears to be just an aimless conglomeration of bovines, but Dr. Petersen has found that actually cows have a rigid and intricate social order!

Cow Society, in fact, is more snooty than New York's 400. Every single cow in the herd has her place. Toward all cows who are *above* her on the social scale, Gertrude is respectful. She will always step aside to let her social superiors be first at the watering trough. But toward all cows who are *below*, she is a little despot.

In every herd there is a top queen. She may not be the prettiest or biggest—in fact she may have only three teats or have a lame leg—but she still runs things her way at all times. Every other cow in the herd is a humble subject.

She wins her position as dowager queen by being the toughest, buttingest cow in the herd. To be queen she had to butt it out with every cow. These butting contests can be fierce, but usually they are half butt, half bluff. The cow that backs down never again challenges the winner. Thus the cow dowager, unlike a human dowager, does not have to lose nervous energy wondering whether her subjects are plotting to unseat her.

Dr. Petersen has found that the queen of them all in a herd has many interesting prerogatives. She has first crack at the best grass in the pasture, and gets the choicest milking stall. When the herd goes walking, she leads the way. And when the herd has to go through a door or gate, the subjects all stand respectfully aside while the queen goes first. Cow No. 2 in the social order usually goes second, and so on. Last cow in the barn is the dope, who has been outbutted by every other cow.

A newcomer in the herd must butt it out with every cow to settle her position. If she outbutts the ruling queen the queen is deposed, and often takes it very badly. . . .

One of the most revealing aspects of Dr. Petersen's study of bovine psychology is the temper and mood he has found in cows at different levels on the social scale. Those near the top, just below the queen, strangely show the most frustration and neurosis and are the most unpredictable milk producers. They are most likely to be the malcontents.

Why? Dr. Petersen believes it is because these cows have won enough victories to taste the pleasures of superiority. They are ambitious, but just miss being aggressive enough in their butting to be top cow. They brood about the honors they might have snatched, and resent being pushed around by the Queen Cow.

In contrast, the cows far down the social scale are accustomed to being pushed around and take it for granted. They aren't ambitious, and are content with their lot. They are the steadiest milk producers.

(from *Animal I.Q.: The Human Side of Animals*)

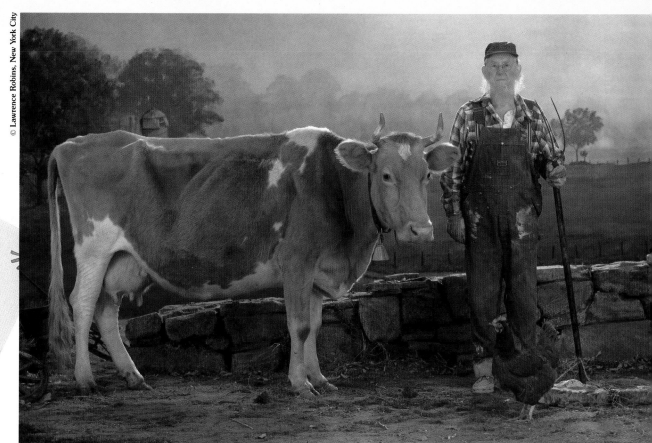

23

Uncommon Cows

Cows are as unique and individualized as people. D. H. Lawrence loved his black cow Susan. An upstate New Yorker named Hughie Hafner always wanted a cow. When Hafner died soon after his wife presented him with one, she had the cow's image engraved on his tombstone. A large papier-mâché cow named "Murph" holds court in a New Haven loft, and children everywhere adore the purple cow and the cow that jumped over the moon. Highly personalized versions of cows appear on myriad tee-shirts, on ice cream trucks, and on the walls of restaurants. Here cows are specific, good-natured members of the family, be they called Bossie, Flossie, Clarabelle, or Bess.

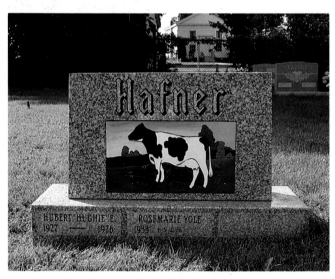

Sculptures by J. Nebraska Gifford, 1987, New York City

24

OGDEN NASH

The cow is of the bovine ilk;
One end is moo, the other milk.

(from *Verses from 1929 On*)

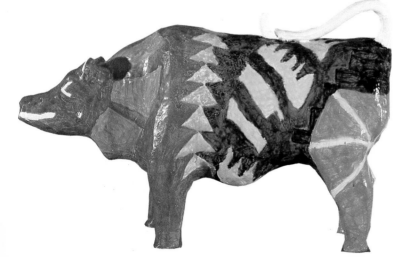

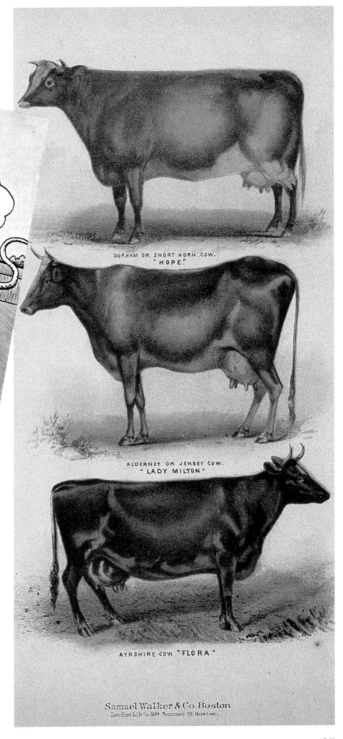

The Purple Cow

BY FRANK GELETT BURGESS

In 1895, "The Purple Cow" appeared in the first issue of the *Lark*, a lighthearted literary magazine from San Francisco. Frank Gelett Burgess, one of the magazine's founders, wrote:

> Reflections on a Mythic Beast
> Who's quite remarkable, at least
> I never saw a Purple Cow
> I never Hope to See One
> But I can Tell you Anyhow
> I'd rather See, than Be One.

Later, after he became widely known as the author of this (and only this) poem, he wrote:

> Ah, yes I wrote the Purple Cow
> I'm Sorry, now I Wrote It!
> But I can Tell You Anyhow
> I'll Kill You if You Quote It!

"Purple Cow," photograph © Art
Rogers, Point Reyes, California

"Love Was Once a Little Boy"

BY D. H. LAWRENCE

How can I equilibrate myself with my black cow Susan? I call her daily at six o'clock. And sometimes she comes. But sometimes, again, she doesn't and I have to hunt her away among the timber. Possibly she is lying peacefully in cowy inertia, like a black Hindu statue, among the oak-scrub. Then she rises with a sighing heave. My calling was a mere nothing against the black stillness of her cowy passivity.

Or possibly she is away down in the bottom corner, lowing *sotto voce* and blindly to some far-off, inaccessible bull. Then when I call at her, and approach, she screws round her tail and flings her sharp, elastic haunch in the air with a kick and a flick, and plunges off like a buck rabbit, or like a black demon among the pine trees, her udder swinging like a chime of bells. Or possibly the coyotes have been howling in the night along the top fence. And then I call in vain. It's a question of saddling a horse and sifting the bottom timber. And there at last the horse suddenly winces, starts: and with a certain pang of fear I too catch sight of something black and motionless and alive, and terribly silent, among the tree-trunks. It is Susan, her ears apart, standing like some spider suspended motionless by a thread, from the web of the eternal silence. The strange faculty she has, cow-given, of becoming a suspended ghost, hidden in the very crevices of the atmosphere! It is something in her *will*. It is her tarnhelm. And then, she doesn't know me. If I am afoot, she knows my voice, but not the advancing me, in a blue shirt and cord trousers. She waits, suspended by the thread, till I come close. Then she reaches forward her nose, to smell. She smells my hand: gives a little snort, exhaling her breath, with a kind of contempt, turns, and ambles up towards the homestead, perfectly assured. If I am on horse-back, although she knows the grey horse perfectly well, at the same time she *doesn't*

know what it is. She waits till the wicked Azul, who is a born cow-punching pony, advances mischievously at her. Then round she swings, as if on the blast of some sudden wind, and with her ears back, her head rather down, her black back curved, up she goes, through the timber, with surprising, swimming swiftness. And the Azul, snorting with jolly mischief, dashes after her, and when she is safely in her milking place, still she watches with her great black eyes as I dismount. And she has to smell my hand before the cowy peace of being milked enters her blood. Till then, there is something *roaring* in the chaos of the universe. When her cowy peace comes, then her universe is silent, and like the sea with an even tide, without sail or smoke; nothing.

That is Susan, my black cow.

And how am I going to equilibrate myself with her? Or even, if you prefer the word, to get in harmony with her?

Equilibrium? Harmony? with that black blossom! Try it!

She doesn't even know me. If I put on a pair of white trousers, she wheels away as if the devil was on her back. I have to go behind her, talk to her, stroke her, and let her smell my hand; and smell the white trousers. She doesn't

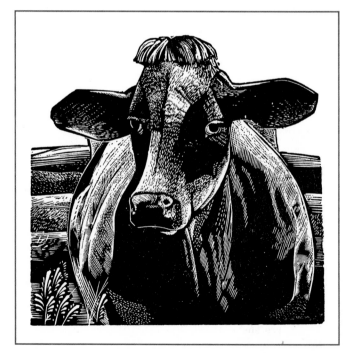

Original wood engraving by Michael McCurdy from *Everything That Has Been Shall Be Again*, Bieler Press, 1981

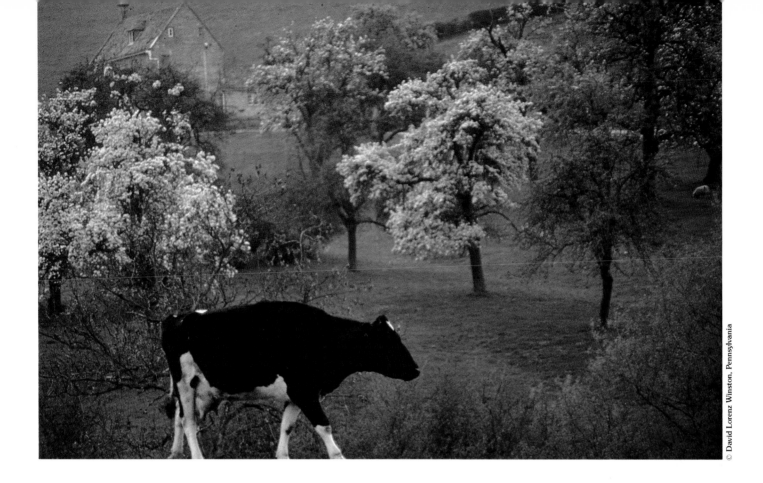

know they are trousers. She doesn't know that I am a gentleman on two feet. Not she. Something mysterious happens in her blood and her being, when she smells me and my nice white trousers.

Yet she knows me, too. She likes to linger, while one talks to her. She knows quite well she makes me mad when she swings her tail in my face. So sometimes she swings it, just on purpose: and looks at me out of the black corner of her great, pure-black eye, when I yell at her. And when I find her, away down the timber, when she is a ghost, and lost to the world, like a spider dangling in the void of chaos, then she is relieved. She comes to, out of a sort of trance, and is relieved, trotting up home with a queer, jerky cowy gladness. But she is never really glad, as the horses are. There is always a certain untouched chaos in her.

Where she is when she's *in* the trance, heaven only knows.

That's Susan! I have a certain relation to her. But that she and I are in equilibrium, or in harmony, I would never guarantee while the world stands. As for her individuality being in balance with mine, one can only feel the great blank of the gulf.

Yet a relationship there is. She knows my touch and she goes very still and peaceful, being milked. I, too, I know her smell and her warmth and her feel. And I share some of her cowy silence, when I milk her. There *is* a sort of relation between us. And this relation is part of the mystery of love: the individuality on each side, mine and Susan's, suspended in the relationship.

(from *D.H. Lawrence and New Mexico*, edited by Keith Sager)

29

© ANM

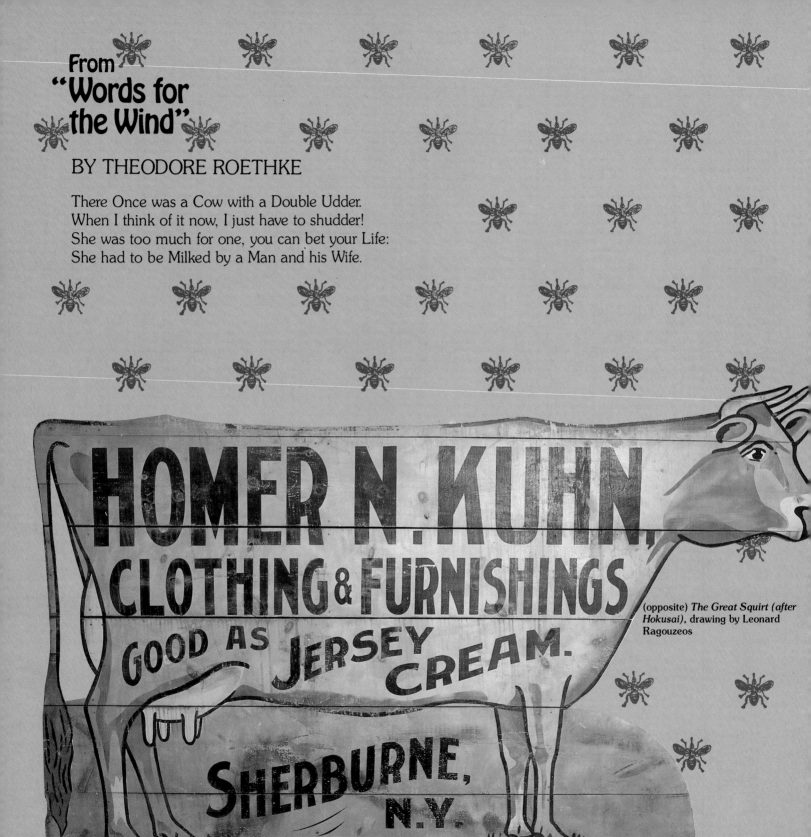

From "Words for the Wind"

BY THEODORE ROETHKE

There Once was a Cow with a Double Udder.
When I think of it now, I just have to shudder!
She was too much for one, you can bet your Life:
She had to be Milked by a Man and his Wife.

HOMER N. KUHN, CLOTHING & FURNISHINGS

GOOD AS JERSEY CREAM.

SHERBURNE, N.Y.

(opposite) *The Great Squirt (after Hokusai)*, drawing by Leonard Ragouzeos

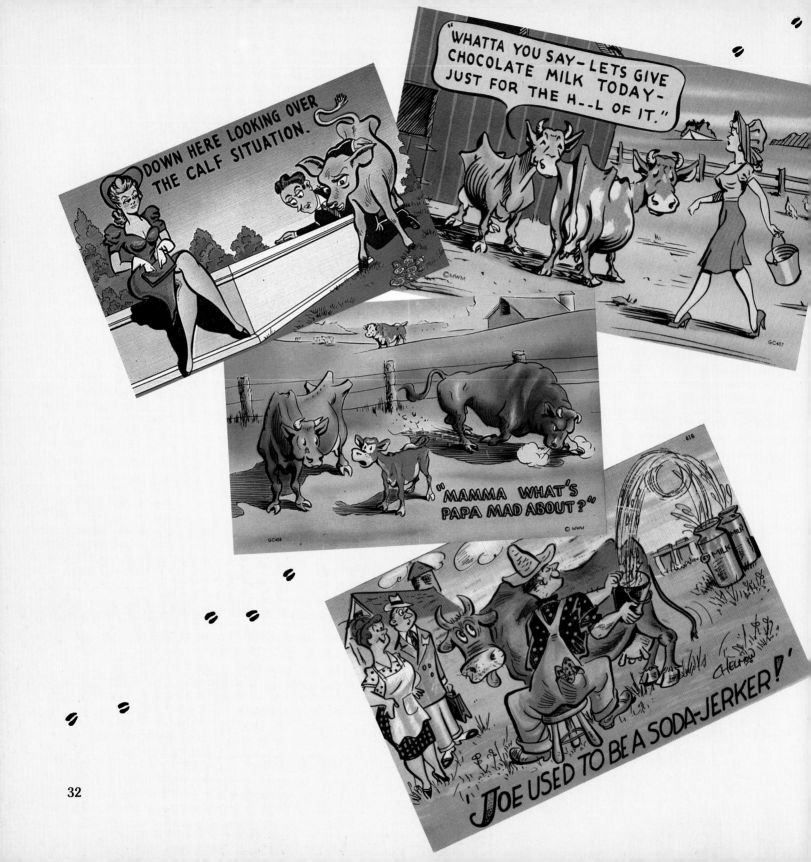

From
The House That Jack Built

This is the Cow with the crumpled horn,
That tossed the Dog,
That worried the Cat,
That killed the Rat,
That ate the Malt,
That lay in the House that Jack Built.

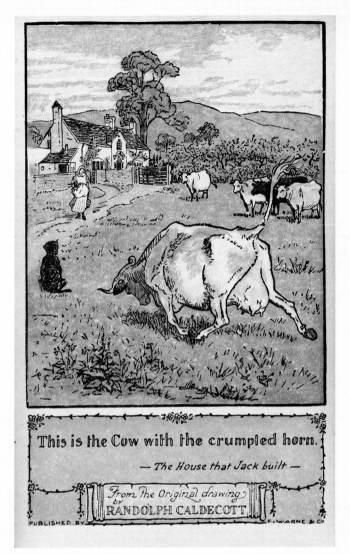

This is the Cow with the crumpled horn.

— The House that Jack built —

From the Original drawing
by
RANDOLPH CALDECOTT

PUBLISHED BY F. WARNE & Co

© Prairie Home Companion

© Woody Jackson

Designed by Marti Blake

© Woody Jackson

© Laughing Stock

© Woody Jackson

34

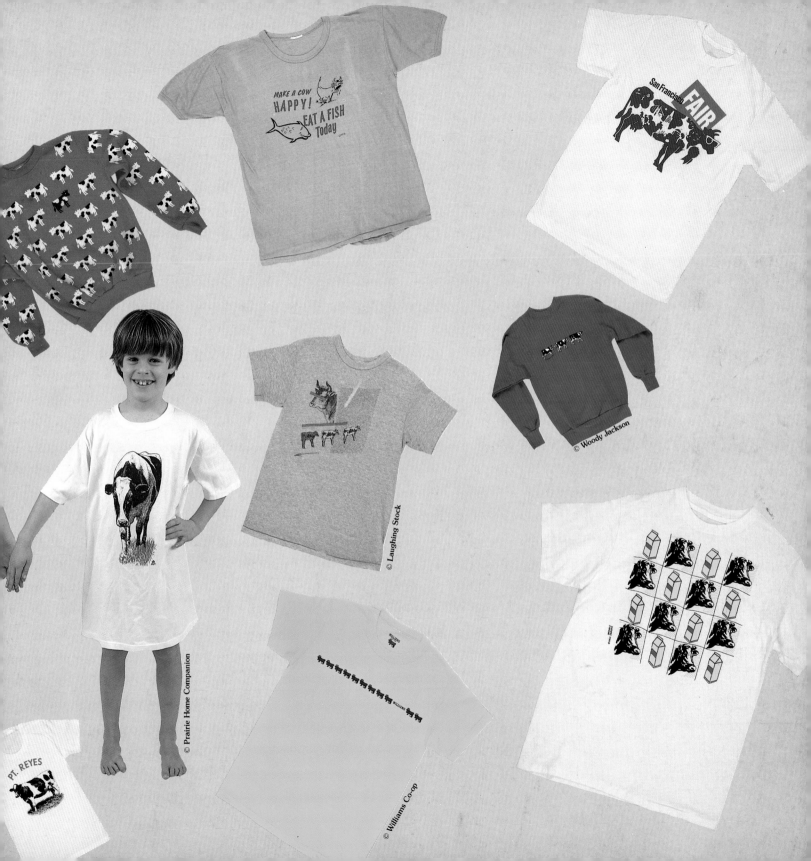

MAKE A COW
HAPPY!
EAT A FISH
Today

San Francisco FAIR

© Woody Jackson

© Laughing Stock

© Prairie Home Companion

PT. REYES

© Williams Co-op

Nursery Rhyme

Hey Diddle, Diddle
The cat and the fiddle,
The cow jumped over the moon.
The little dog laughed
To see such sport,
And the dish ran away with the spoon.

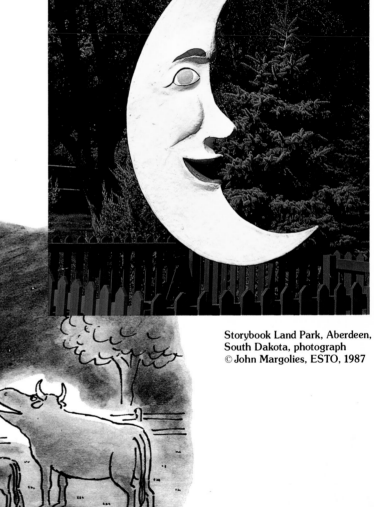

Storybook Land Park, Aberdeen,
South Dakota, photograph
© John Margolies, ESTO, 1987

Drawing by S. Gross, © 1983 *The New Yorker*

37

"Son, your mother is a remarkable woman."

Commercial Cows

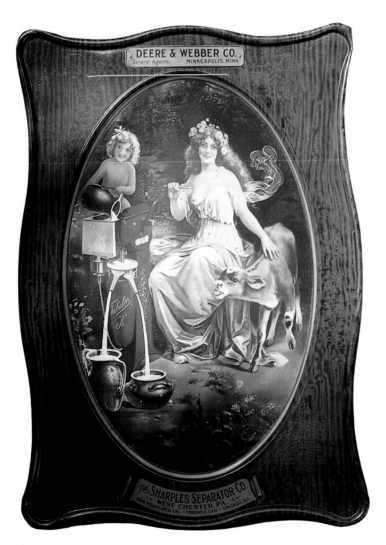

As our perceptions and uses of cows evolved during centuries of civilization and domestication, we set about giving the large, helpful animals specialized tasks to perform. We humanized cows, giving them names, sorting out their functions. Some cows are just for milk, others just for meat. Breeding becomes a big business. We measure bulk, itemize yields, turn each cow into a well-tuned machine designed to give the most of everything good she's got. And as cows became a specific part of the productive world, many cow-derived words became an integral part of the language (see Glossary).

From farm to funk, from folk art to fantasy, from an Australian postage stamp to a Madison Avenue ad agency, from Walt Disney's Clarabelle to the Borden Company's beloved Elsie, from a 1940s butter box to a 1980s cookie tin, we have assembled tributes to the obliging cow who in her wondrous way has buckled down to work for us.

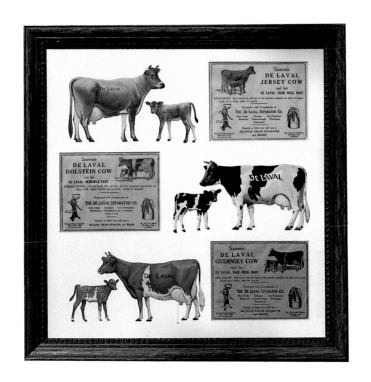

39

Dear Ms. Gwathmey:

I'm from North Dakota, and while reading through my county paper, Benson County *Farmer's Press*, noticed a small article stating you're looking for information regarding cows for a book you are writing. My grandfather was a farmer and had a few head of cattle. One of the things he always said which to the day amuses me was referring to their waste as "Minnesota chewing gum."

My younger brother and I always looked forward to the daily trips out to the pasture with grandpa for feeding time. The cattle would follow behind the old, beat-up red truck waiting for their meal. For the more lazy cows he would give a loud yell of "Come Baas!" Besides the hay there were always a few salt blocks for the herd. I recall there was also a walk-through type stall with cloths of oil around it. The oil would keep flies off the hide of the cows so they wouldn't be bothered so much. In the winter the cows were brought to the farm and lived in the barn yard. They were really very gentle and allowed you to walk among them. However, I do remember grandpa tossing me over the fence by the seat of my pants because one cow protecting her newborn calf was charging us. She didn't mind grandpa taking a look at her newborn, he was trusted by them. The bull, however, never did seem to like anyone. Many times I ran and jumped over the fence with him right behind me. The old grouch never did catch me. My brother and I did like to tease the cattle and sometimes got them very upset. Grandpa would have to use his whip on them to settle them down.

One thing I could never stand was branding the cattle. It seemed so cruel. The cattle would be herded into a pen and then one at a time herded into a stall. When that hot iron hit them they bucked like crazy and almost screamed. At least branding isn't quite as common these days. Now they simply tag their ears.

This isn't much as far as useful information goes for an informative book on cows. Consider it a break from reading up on the more important facts. It's rather hard for me to imagine someone as interested in cattle as you are and that you would write a book on them. Cows are so common in this area you really don't think of them as being of much interest to a New Yorker—or anyone else for that matter.

To have cattle is a lot of work for a farmer. Most farmers have them as an extra, dependable income. That is extremely necessary now when crop prices are so low. The richer farmers are the ones in the cattle market. Most of the people around here have beef cattle. Only a handful deal in dairy cattle. I'm not certain, but I believe less people get into dairy cattle because a bigger investment is needed for the equipment and care of dairy cattle compared to beef.

One thing to remember if you're ever in North Dakota—watch the roads and ditches for cows and deer when you're driving.

Lori Streifel

Sincerely,
Lori Streifel
Devils Lake,
North Dakota

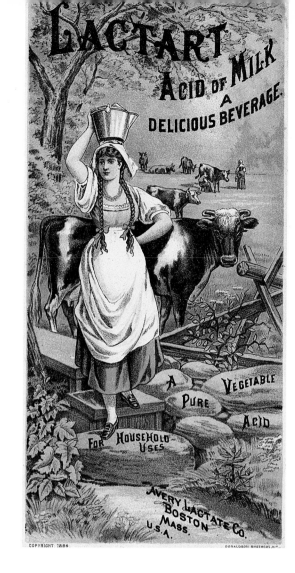

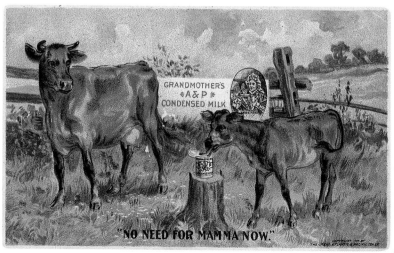

GRANITE IRON WARE

FOR KITCHEN AND TABLE USE

COPYRIGHT 1884.

FACTORY NO. 849, F

JERSEY COW 11

How the Stomach of the Cow Works

A cow's stomach is divided into four parts. As she grazes she stuffs grass into herself as fast as she can, without chewing it. The feed goes into her rumen, a huge sac that holds 60 gallons of food fluid. After she has eaten her fill, she looks for a shady spot to lie down and starts chewing her cud, or ruminating. She burps up a mouthful of the previously swallowed grass and starts to chew it, so that it will be easier to digest. She then swallows it back down to the rumen, which houses a vast population of bacteria and protozoa. These microorganisms have the ability to break down and digest cellulose, the tough outer-covering of plant cells. Without these "bugs" the cow could digest grass no better than we can. Once chewed and back in the rumen, the food passes along through chambers, where both the original grass and the rumen organisms that helped digest it are further digested. This process allows the cow to extract energy, and thus make milk, from parts of the plant that would otherwise be wasted.

NEW ENGLAND MINCE MEAT.

T. E. DOUGHERTY · PORT BYRON, N.Y.

LE LAIT

Bouteilles pour le lait

Jarre à lait

Baratte à manivelle

Bidon à lait

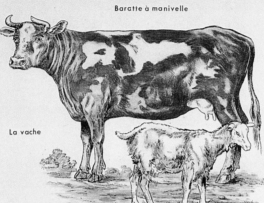

La vache

Chèvre

Mesure à lait

Laitière

Baratte à main

Fromages

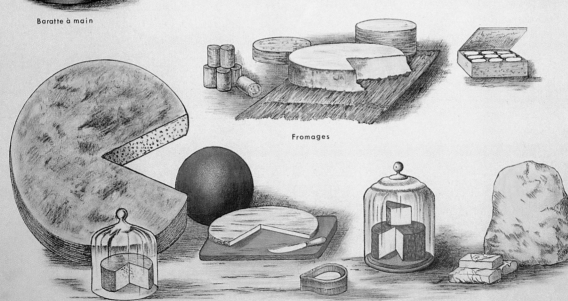

Fromages

Beurre

Reproduction interdite

Mobilier et Matériel pour l'Enseignement, LES FILS D'ÉMILE DEYROLLE, 46, rue du Bac, Paris

Imp. Richier - Laugier 734-70-08

© Les Fils D'Émile Deyrolle, editeurs 46 rue du Bac, Paris

Definition of a Cow

A big-city schoolboy describes a cow something like this:

A cow is a completely automatic milk-manufacturing machine. It is encased in untanned leather and mounted on four vertical, movable supports, one on each corner.

The front end contains the cutting and grinding mechanism, as well as the headlights, air inlet and exhaust, a bumper and foghorn.

At the rear is the dispensing apparatus and an automatic fly swatter.

The central portion houses a hydrochemical conversion plant. This consists of four fermentation and storage tanks connected in series by an intricate network of flexible plumbing. This section also contains the heating plant complete with automatic temperature controls, pumping station and main ventilating system. The waste disposal apparatus is located at the rear of this central section.

In brief, the externally visible features are: two lookers, two hookers, four stand-uppers, four hanger-downers, and a swishy-wishy.

There is a similar machine known as a bull, which should not be confused with a cow. It produces no milk, but has other interesting uses.

(from *American Red Angus*, September, 1966)

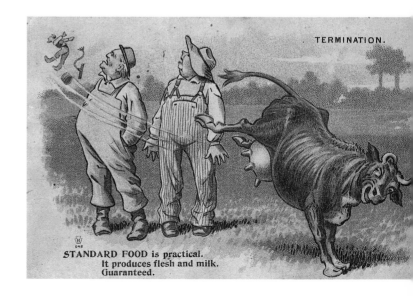

TERMINATION.

STANDARD FOOD is practical.
It produces flesh and milk.
Guaranteed.

44

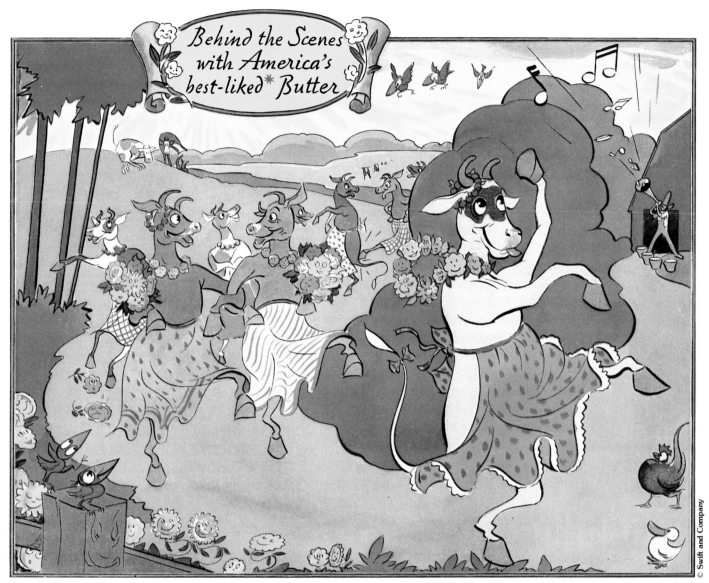

Behind the Scenes with America's best-liked* Butter

Brooksie and her sisters—showing you how really happy they are to provide the marvelous cream used in making Swift's Brookfield Butter.

After settling down, the first thing people acquired (after a plot of land and a roof over their heads) was the family cow. From there, it was just a small step to commercial herds and farms. Milk, butter, cheese, and ice cream became household staples with the advent of pasteurization, refrigeration, and mechanization. Thus the dairy industry was born, and with its birth came advertising and the anthropomorphized cow. Suddenly Brooksie, Bossie, *La Vache Qui Ri*, and Elsie were everywhere, thoughtfully and charmingly extolling the virtues of their healthful products. Looking at some of these bovine images reminds us of the wonders of the cow—nature's own food factory and a selfless helpmate to human neighbors.

45

The Story of Elsie the Borden Cow

E lsie, the Borden Cow, is one of the best known and loved American trademarks. Since the 1930s, people have enjoyed the friendly, cheerful representative of the Borden Company, and millions have visited her at shows and special events throughout the U.S. and Canada.

Elsie was created in the 1930s when the dairy industry had its share of public relations and consumer problems. Well-publicized "milk wars" between farmers and dairy processors pictured the large dairies as evil moneymakers. Borden decided that a friendly, humorous approach had the best chance of changing public opinion.

A series of ads featuring a variety of cartoon cows was run in medical journals to the delight of doctors who asked for reprints for their waiting rooms. Borden also began experimenting with newspaper ads, and in 1938 a radio commentator brought Elsie to life by singling her out in a commercial that he read on a coast-to-coast broadcast. By 1939, Elsie had made her debut in national consumer magazines and was being used for local community promotional programs by all of the company's milk plants.

When the 1939 New York World's Fair opened, the focal point of the exhibit was a modern automatic milking machine, the "rotolactator," where 150 cows were milked each day. The question fair visitors most often asked was which of the cows was Elsie.

Borden realized that Elsie's popularity was strong and that many people were going to be disappointed if Elsie wasn't on display. Of all the cows in the exhibit, the most beautiful was the seven-year-old blueblooded Jersey whose name was "You'll Do, Lobelia." Twice each day she was dressed in a lavishly embroidered green blanket and milked separately. The public loved her, and that is how the live Elsie was born.

© 1941 The Borden Company

LIEDERKRANZ—HIGH SPOT OF MEALS!

A special "barn colonial" boudoir was designed featuring many whimsical props such as milk bottles for lamps and churns for tables.

Elsie's husband, Elmer, and her first daughter, Beulah, were born only a few weeks apart in 1940. Elsie was asked to play the role of a cow named Buttercup in the movie, *Little Men*, starring Jack Oakie and Kay Francis. Borden was interested in the idea but still needed an exhibit for the World's Fair. In addition, Elsie was soon to be a mother. Elmer was suddenly invented, and the boudoir was disarranged to give the appearance of a husband left to do the housekeeping. Elmer was later loaned to the Borden Chemical Division as the spokesman for their new, white glue product, and he's been there ever since!

When Elsie completed the movie and returned to the World's Fair she was accompanied by her baby, Beulah, and was even more popular. More people visited the boudoir than any other exhibit at the World's Fair.

Elsie became a well-known celebrity in the New York area and was the guest of honor at many social functions. Most of her appearances were for charity, including a tour during which she raised $10,000,000 in U.S. War Bonds. By 1941, the Elsie cartoon magazine ads were almost as popular as the editorial content. Meanwhile, the live Elsie was now traveling throughout the country in a new, mobile boudoir.

Both the cartoon and live Elsie took on a new family member in 1947. A contest to name the boy calf brought in one million entries, the largest response ever to a contest at that time. The name the judges picked was Beauregard, in honor of General Beauregard's association with the Battle of Bull Run. Beau replaced Beulah as Elsie's traveling companion.

During the sixties, an attempt was made to retire Elsie and develop a new trademark, but a survey showed the friendly cow was the best known and loved trademark in the country.

In 1971, an animation film house began developing a new cartoon Elsie for television commercials. The live Elsie was reactivated for the official opening of the Borden Ice Cream Parlor at Walt Disney World in Florida, and to greet the governor of Ohio and the mayor of Columbus when Borden transferred its corporate headquarters to Ohio's capital city.

Elsie is once again popular with a new generation of Borden customers, and her travels have taken her to the Kentucky Derby, the Indianapolis 500, the Rose Bowl parade, and a guest appearance on "What's My Line?"

Borden is proud to have shared the fun and imagination of Elsie, the Borden Cow, and to have created a character that continues to be a symbol of wholesome, quality products.

(© The Borden Company)

(far left) *Elsie and the Beverly Hills Crowd*, painting from the "Elsie Goes Hollywood" series by Pat Nugent, Philadelphia

47

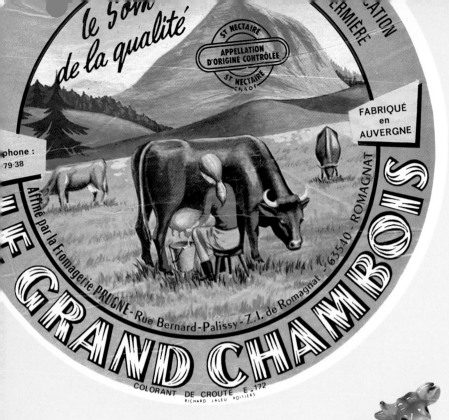

le 5om de la qualité

ST NECTAIRE
APPELLATION D'ORIGINE CONTRÔLÉE
ST NECTAIRE CN40F

FABRIQUÉ en AUVERGNE

phone : 79-38

Affiné par la Fromagerie PRUGNE - Rue Bernard-Palissy - Z.I. de Romagnat - 63540 - ROMAGNAT

LE GRAND CHAMBONS

COLORANT DE CROUTE E-172
RICHARD LALEU POITIERS

BOSSIE'S BEST
FOUR QUARTERS
BOSSIE'S BEST
4 B's
BRAND BUTTER
ONE POUND NET

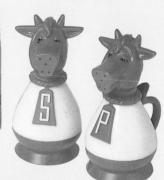

S P

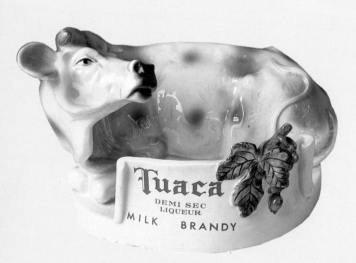

Tuaca
DEMI SEC LIQUEUR
MILK BRANDY

48

CAMEMBERT FABRIQUÉ EN NORMANDIE
AU LAIT CRU
RÉO
MOULE à la LOUCHE
45 POUR CENT DE MATIÈRE GRASSE
RÉAUX - 50430 LES...
LABEL ROUGE
VÉRITABLE CAMEMBERT
CAT DU
ORIGINE GARANTIE DE NOR...
NORMANDIE

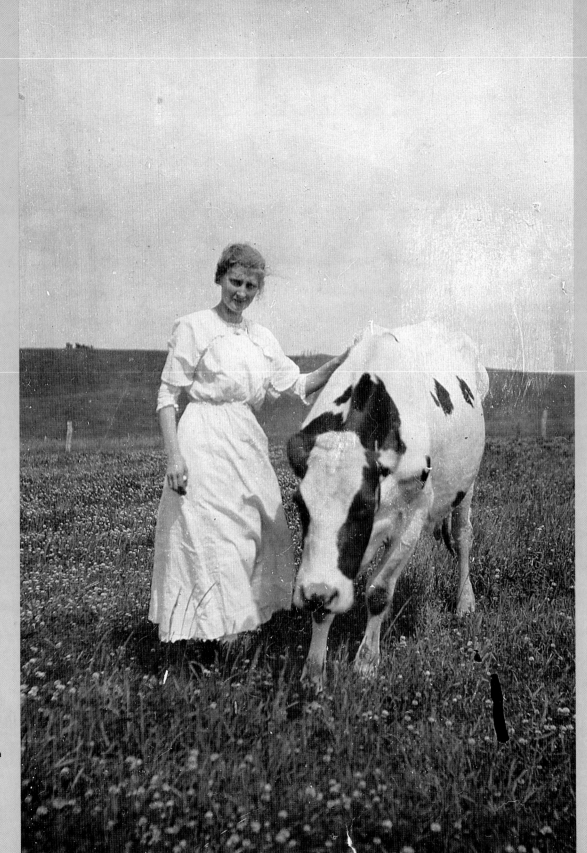

Margaret Weideman on
an Iowa farm, 1915

Dear Ms. Gwathmey:

I grew up on an Iowa farm in the 20s and 30s and learned to milk when I was five years of age. My older sister and I had to get up early to help with the milking before walking across the fields to go to country school.

We milked Holstein cows and sold the cream to the creamery and fed the milk to the hogs. Washing the cream separator was our job, too, and we took turns, but it was rather a tedious job.

After milking, the cows were turned out to pasture, and every afternoon one of us children would have to go and chase them into the barn. Most of the time they went willingly—and as I recall, there was a "lead cow" who always was in front of the herd as the cows headed home. I always liked this task—our cows were very gentle and getting them to go to the barn was rarely a problem.

The cows always went to their own places in the barn, and if one made a mistake the cow who belonged in that stall would bunt the other out of her place. My father had painted name tags in big letters over each cow's stanchion—and he always told us the cows went to the right stall because they could read their names!

Our cows had names and we knew them by name. They were registered Holsteins, and we had papers on them; their registered names would be rather elaborate and usually three or four names, such as "Star Neta Iowana" or even longer, but would be called "Star" for short. In our family, new calves were always named with the same first initial as the mother. (The one exception: if a calf was born on a member of the family's birthday, the calf was named for that person.) Many of our cows had names such as "Daisy" or "Star" or "Bluebell," but sometimes they were named "Cordelia" or "Annabell Lee" or "Marguerite."

We depended upon cows for our livelihood—in many weeks of the Great Depression the cream check was our only source of income. We had 20–25 cows in our herd—small by today's standards. Feeding the calves was another chore that we girls did. The calves were separated from their mothers shortly after birth and were taught to drink from a pail. One dipped one's fingers in the milk, and the calf would suck the milk from the fingers—then soon it would get the idea of drinking. Those calf tongues were very rough!

We kept the heifer (female) calves and sold the males. We always felt sad to see them go—usually sold for veal—because we got to know them as we fed them. Once we had a cat that would curl up beside each newborn calf in turn and sleep beside it.

Sincerely,
Signe Cooper
Middleton, Wisconsin

Photograph © Nancy Sullivan, Vermont

51

Dear Ms. Gwathmey:

Talk about mother love—listen to this!

A city born and bred woman, I had been married a short time and was new and confounded by my husband's farm in Upstate New York, which had become my new home. I looked forward to loving the animals, especially the cows, which always seemed so docile and sweet in the milk ads.

Well, this fine snowy morning in January my husband said to me, "I am going to leave the newborn calf in the barn because it is too cold for her outdoors. Mother Cow will stay in the field. Don't open the barn door under any circumstances."

Relaxed with these specific instructions, I carried on my household chores when to my utter dismay I saw Mother Cow heading straight for the barn. How she got out of the field I will never know.

In my foolish innocence, I thought I could head her off. I rushed out and tried to divert her attention from the barn, but she would have none of this, just pacing back and forth in front of the barn and casting hateful looks in my direction where I stood helplessly.

Thank God, my husband finally came home. I had had enough of this nasty cow. But it was not the end.

The first thing my husband did was open the barn door. "Good, I thought, that should make her happy and good riddance."

She started toward the barn door. Then stopped, looked at me straight in the eye, and then to my horror, spat full in my face!

This is the truth and I have never been the same since.

Nellie Valli

Nellie Valli
Valley Stream, New York

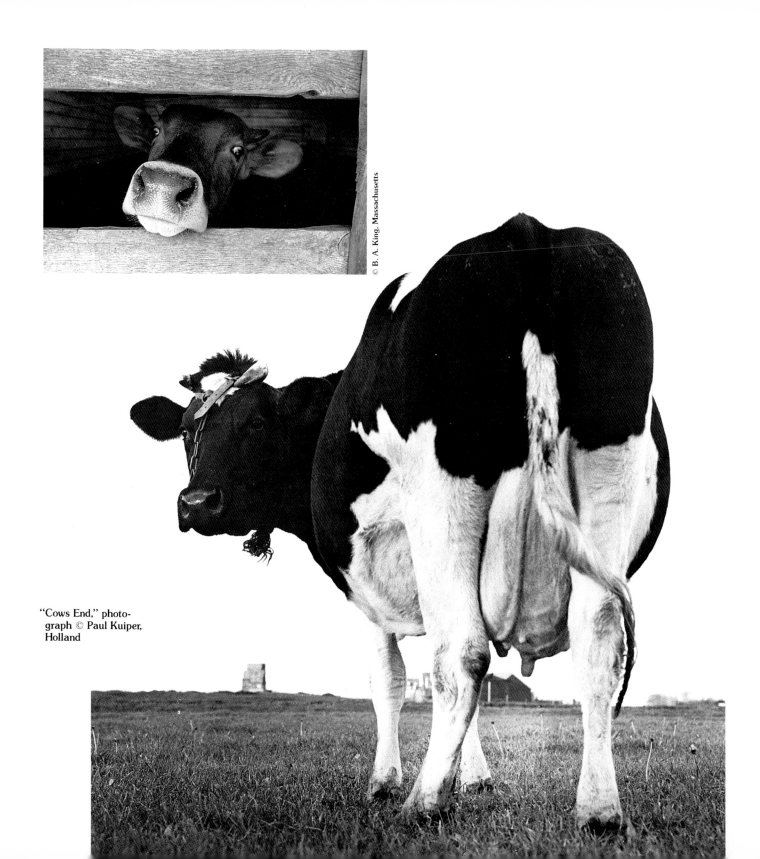

"Cows End," photograph © Paul Kuiper, Holland

Decorative oversized advertising
balloon for the 1986 National
Grange Session in Madison,
Wisconsin

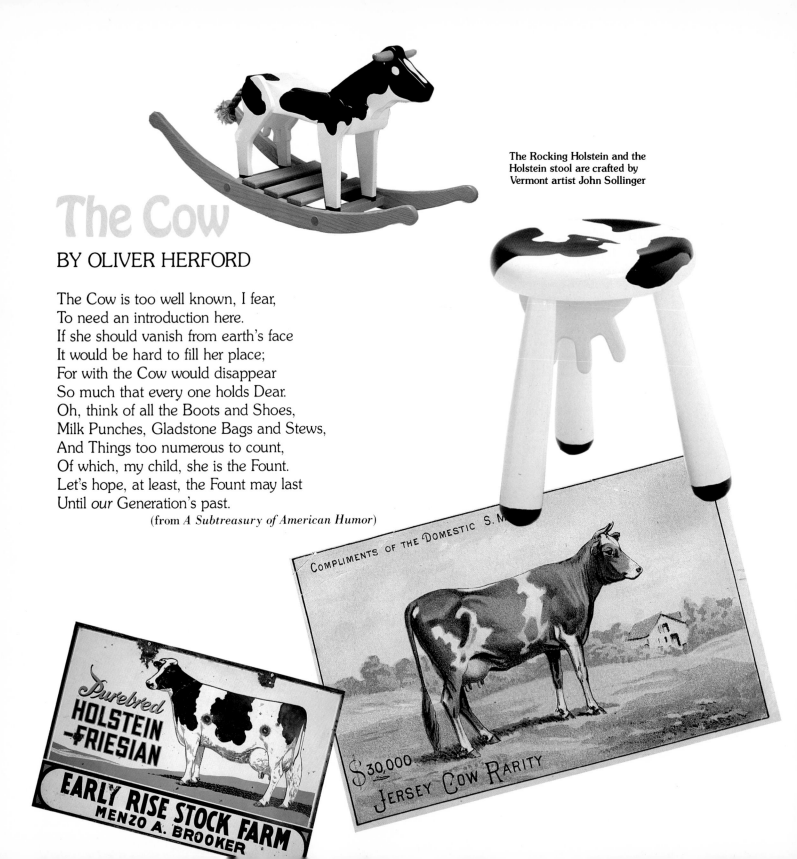

The Cow

BY OLIVER HERFORD

The Cow is too well known, I fear,
To need an introduction here.
If she should vanish from earth's face
It would be hard to fill her place;
For with the Cow would disappear
So much that every one holds Dear.
Oh, think of all the Boots and Shoes,
Milk Punches, Gladstone Bags and Stews,
And Things too numerous to count,
Of which, my child, she is the Fount.
Let's hope, at least, the Fount may last
Until *our* Generation's past.

(from *A Subtreasury of American Humor*)

The Rocking Holstein and the
Holstein stool are crafted by
Vermont artist John Sollinger

COMPLIMENTS OF THE DOMESTIC S. M.

$30,000 JERSEY COW RARITY

Purebred
HOLSTEIN
-FRIESIAN

EARLY RISE STOCK FARM
MENZO A. BROOKER

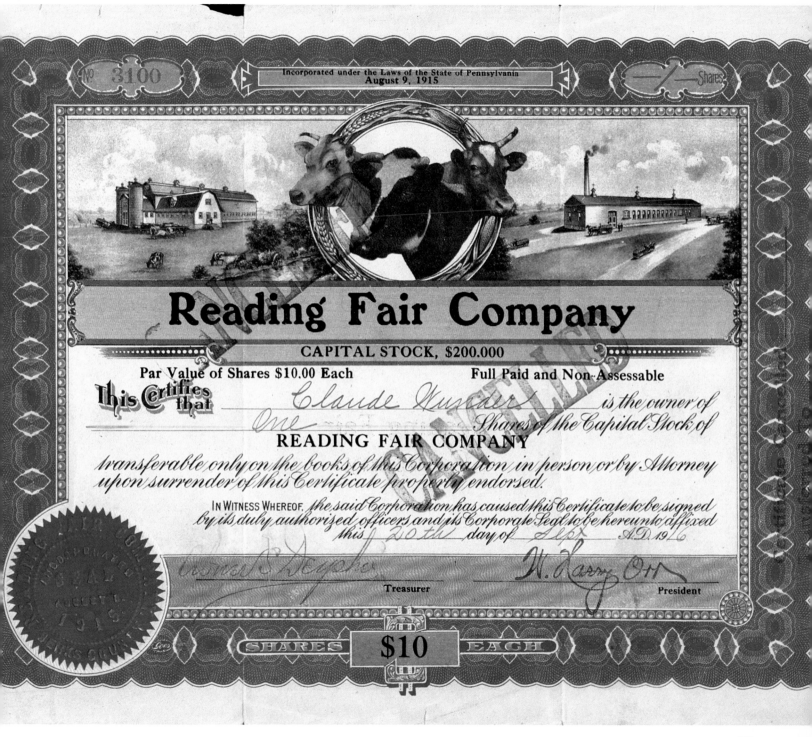

No. 3100

—/— Shares

Reading Fair Company

CAPITAL STOCK, $200.000

Par Value of Shares $10.00 Each

Full Paid and Non-Assessable

This Certifies that _Claude Wunder_ is the owner of
One Shares of the Capital Stock of
REDING FAIR COMPANY

transferable only on the books of this Corporation in person or by Attorney
upon surrender of this Certificate properly endorsed.

IN WITNESS WHEREOF, the said Corporation has caused this Certificate to be signed
by its duly authorized officers and its Corporate Seal to be hereunto affixed
this _20th_ day of _Sept_ A.D. 19_16_

Treasurer

President

SHARES $10 EACH

57

THE INTRUDER!

NOONDAY HEAT

58

WASHBURN·CROSBY CO.·MERCHANT MILLERS

MINNEAPOLIS, MINN. U.S.A.

WASHBURN CO'S COARSE BRAN MINNEAPOLIS

COARSE BRAN MINNEAPOLIS, MINN.

WASHBURN CROSBY CO'S COARSE BRAN MINNEAPOLIS, MINN.

BROAD AND FLAKY

UNIFORMITY GOOD QUALITY

USE OUR FLOUR. ALL DEALERS KEEP WASHBURN CROSBY CO'S FLOUR.

Hershey's Chocolate

FOR BREAKFAST, LUNCH AND DINNER

TRY HERSHEY'S MILK CHOCOLATE

Manufactured by HERSHEY CHOCOLATE CO., LANCASTER, PA. U.S.A.

TRADE MARK

59

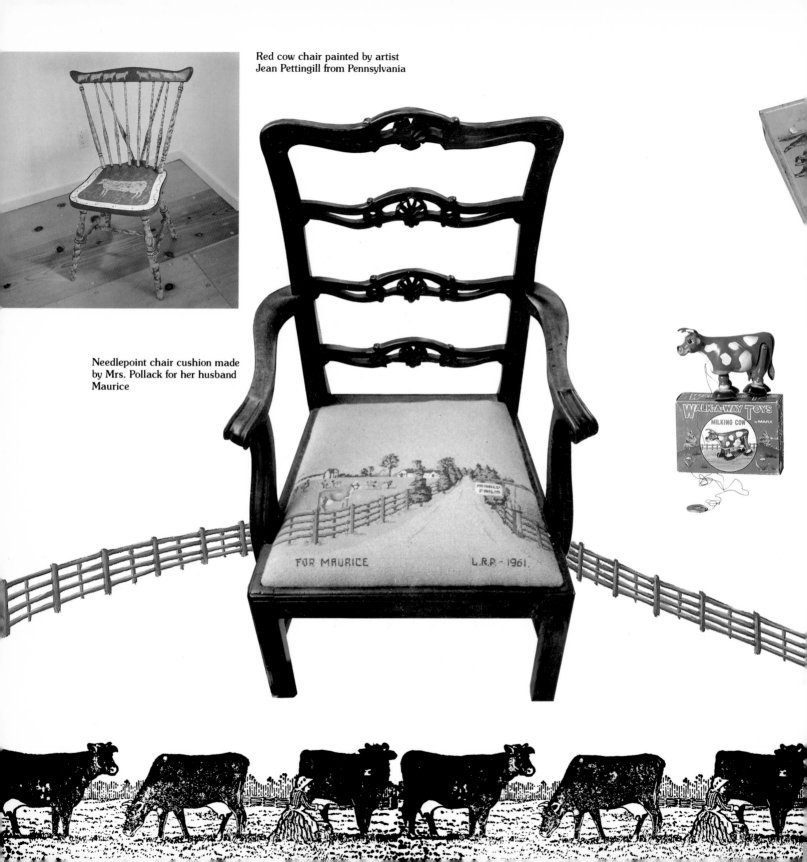

Red cow chair painted by artist
Jean Pettingill from Pennsylvania

Needlepoint chair cushion made
by Mrs. Pollack for her husband
Maurice

FOR MAURICE L.R.P.-1961

WALK-A-WAY TOYS
MILKING COW by MARX

Tin lasso game from the 1940s

Assorted cow bags, from Peru,
Point Reyes, California, and from
Philadelphia artist Bob Reinhardt

61

The Great Mother Cow

THE INGENIOUS MOTHER.

The archetypal image of the all-nurturing great mother cow is prehistoric, universal, and symbolic. She is the earliest substitute for our own mothers as we wean ourselves to her bountiful milk. As children we learn early that "the cow says moo," and we count cows posing by the roadside in a popular car game called "Cows."

From the early Egyptian worship of Hathor the cow-goddess to the I Ching's advice that "care of the cow brings good fortune"; from Gandhi's love of the cow as "a poem of compassion" to feminist Susan Griffin's impression of a great cow "who stands ready for the bull, who is faithful, always there"; we can see the scope and intensity with which cows are integrated into this precognitive aspect of human nature.

Spanish Proverb

Let a woman into paradise
and she'll bring her cow along.

62

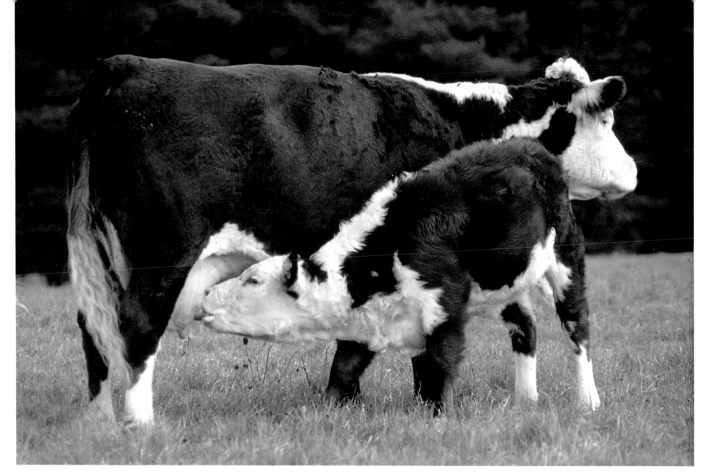

"Cow and Calf," photograph
© David Lorenz Winston,
Pennsylvania

Goddess of the Hearth

BY HELEN M. LUKE

It is the crucial matter of the choice of fuel that is the subject of the I Ching hexagram #30, which is the doubled trigram meaning *Fire*. It is called "The Clinging," directing attention to the fact that fire must cling to something in order to burn at all. The words of the Judgment are somewhat of a shock. "The Clinging. Perserverance furthers. It brings success. Care of the cow brings good fortune." The image of the cow is so remote from either fuel or fire, it seems, that we are bewildered. A footnote in the Baynes-Wilhelm translation points out that in the Parsee religion the worship of fire is also associated with the cow, so that it is not a purely Chinese image.

If we look a little deeper, however, we begin to see how true it is that the moment we cease to "care for the cow," the fire either goes out or rages out of control to our destruction. Ahura Mazda, god of light and wisdom in Zoroastrianism, was nourished on the milk of the cow when he came to earth. Only the particular essence of the feminine principle symbolized by the cow can maintain the steady flame of the inner light. For the cow means something more specific than simple motherhood. She stands in our imagination as an image of the slow, patient chewing of the cud which turns the grass of the earth into human food. Receiving the seed of the fiery bull, she conceives, but the milk which she produces for her young may also, if consciously drawn upon, provide nourishment not only for human beings, but even for the god incarnate himself. The cow is the passive, feminine heat of unremitting attention without which there can be no transformation by fire. The alchemist mixing his raw materials with superlative skill in his retort could have achieved nothing if he had not tended the fire underneath it day and night, so that it might not burn too high or too low. So also must the cook watch in her kitchen, the smith in his smithy, and, most earnestly of all, every person who seeks to transform the raw material of his or her life into the gold of consciousness. For if the fire goes out or burns too fiercely, it is very likely that he must begin all over again. It is only if we will drink daily of the milk of the "cow" within us that we can find strength for this. One word for this inner care of the cow is rumination, which is derived directly from the chewing of the cud.

(from *Woman, Earth and Spirit: The Feminine in Symbol and Myth*)

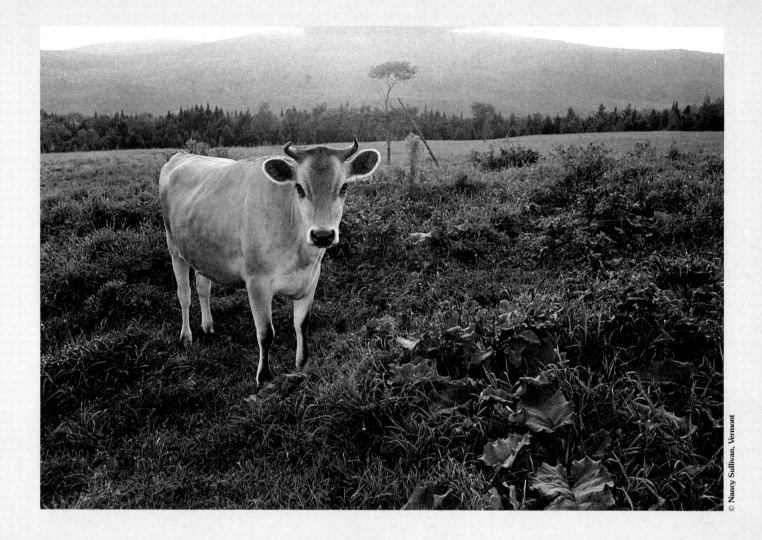

From "Song of Myself"

BY WALT WHITMAN

The cow crunching with depressed head
surpasses any statue . . . I think I could turn
and live with animals, they are so placid
and self-contained.

<div align="right">(from Leaves of Grass)</div>

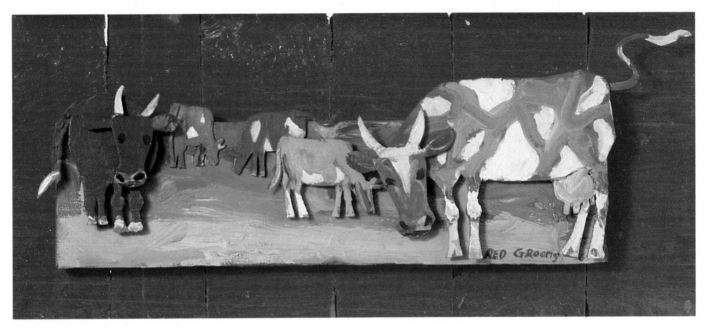

Cows, sculpture by Red Grooms, from the collection of Robert Abrams, New York City

Miles per Cow

A stranger was walking from Stroud to Cirencester. After plodding up Chalford Hill, he felt puffed and wondered how much further he had to go. Just then a farmer came by, walking the other way.

"How far to Cirencester?" asked the stranger.

"With a cow or without a cow?" replied the farmer.

"Without a cow, I suppose," said the stranger.

"I can't tell 'e then," said the farmer, "I never done it without a cow."

(from *The Birthday Book of Beasts*)

Crossing, painting, 1983-85, by William Beckman. Courtesy of Allan Frumkin Gallery, New York City

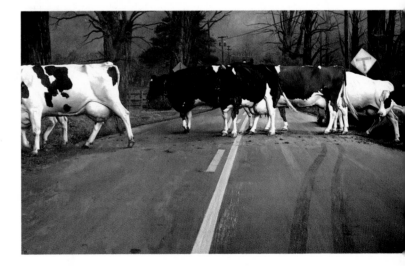

The Cows at Christmas

BY MOLLY DOUGLAS

When Christmas Eve comes to the farm the everyday chores take on a special meaning. The cows welcome us with a soft low. I do believe it is softer, more gentle, this night as if they anticipate a coming. Their flanks are warm, and milk froths, not into a pail (these modern times) but into the machine jar, the motor chugging in the background, the milk carried to sterilized containers. This we welcome, as we welcome our sturdy insulated barn, which keeps the bitter winds at bay. But the cows are the same. Calves still cry plaintively for their milk and the heifers join their cry wishing they were calves again, or perhaps grown cows getting special rations and personal attention.

We still do the same time-honored labors. Like putting hay in the mangers. Its good, honest smell reminds us of hot sunshine and a busy tractor. We bed the cows in deep straw, while outside the snow is crisp and our breath comes in frosty puffs.

Last Christmas Eve I did something I shall not do again. It was close to midnight. The cows were milked, left in a deep bed of straw. The tree was decorated, the children insisting where each colored ball and star would go. The turkey was ready to go in the oven early Christmas morning, mince pies were waiting, a bowl of oranges (mandarins announcing Christmas) and nuts and toys were under the tree.

All evening the family hid in their rooms to appear with gaily wrapped gifts, shouting "Don't look!" if anyone peeked. At last they slept. My husband filled stockings. Some said they were too old for that, but hung them there just the same. Tired from the day's chores, my husband dozed in his chair, and I with nothing more to do, put on my parka and went outside.

It was cold, and the moon rode high. I was sure I had never seen the stars shine more brightly, scattering stardust so deep I wanted to gather it in my hands. I looked up and wondered which star had led the wise men. Any would have been worthy of such a night. I walked softly to the barn. I was going to see if the cows really do kneel on Christmas Eve.

I like cows. They are patient beasts. Grateful for all we give them, they give back—everything. Their milk, their calves and finally their meat and their hides.

It is as if they say "Keep calm. Don't fuss. Have faith. There are warm days ahead. Shady trees and green grass. It hasn't let you down so far has it?" Cows are wise creatures. Knowing this and that cows are said to kneel on Christmas Eve to worship the Christ child and honor their ancestors who were there at the birth, I went to the dairy and lifted the latch. Suddenly my hand was stopped and I stood as if a voice had spoken.

"Look," it said, "if you go in the dogs in the straw will bark and disturb the cows, and the cows won't kneel if you stare. Must you have proof? What if the cows don't kneel? You will always doubt afterwards. You will even wonder if they ever did kneel."

I pushed my hands deeper into my parka pockets and looked up. What a bright cold night it was and how thankful we should be. We live in a peaceful country. Our cows are deep in straw and our children snug in bed. Farming isn't an easy way to make a living, but it has taught us much— that if we are giving, generous and kind, we are repaid in kind. The cows teach us that. Suddenly I stopped at a sound from the barn.

The cows' chains were rattling, one after the other. A pause and then the last chain. That would be Betty. She is getting a little stiff. It must be midnight. They are kneeling. How could I ever have doubted them?

(from *Christian Science Monitor*,
December 18, 1979)

The Cow

BY ROBERT LOUIS STEVENSON

The friendly cow all red and white,
I love with all my heart;
She gives me cream with all her might,
To eat with apple-tart.

She wanders lowing here and there,
And yet she cannot stray,
All in the pleasant open air,
The pleasant light of day;

And blown by all the winds that pass
And wet with all the showers,
She walks among the meadow grass
And eats the meadow flowers.

<div align="right">(from A Child's Garden of Verses)</div>

(opposite) Cover drawing by
Jenni Oliver, © 1987 *The New
Yorker*

Dear Ms. Gwathmey:

I read in the last issue of *The New Yorker* that you are compiling a book about cows and wished to receive recollections. I don't know exactly what you have in mind, but I assumed that you meant personal stories, sort of "Cows I Have Known."

When I was a child, we had a farm that we visited each weekend. It had belonged to my grandfather, and my father was brought up there. It was (and still is) about an hour out of Dallas, on the flat sticky-clay blacklands that used to grow cotton. My dad ran about a hundred head of white-faced Herefords, with a few Brahmin (in Texas, pronounced "Brema") mixed in, beef cattle that he took to market or had slaughtered for our own table. We knew those cows, gave them names, and knew which calf belonged to which mother. We kids never liked it when my father took a steer off to the slaughterhouse, or a calf off to the auctions. Its mother would run along the barbed wire fence, bawling after the trailer. When we got back white-paper-wrapped packages from the freezer locker plant, containing parts of Curly or Daisy, we would refuse to eat dinner. It also didn't taste that good, which may have helped our conscientious objections. Grass-fed beef tastes different from the corn-fed beef you buy at the grocery store.

In the early sixties, Black Angus cattle became popular, and so my father decided to order some breeding stock to upgrade the herd. A young bull and five cows, all with papers and fancy names, were delivered. We loved them! They were fat, glossy black, and sweetly placid. I don't remember what their official names were, but we called the bull Prince Charlie. We could pet him and he loved to eat Range Pellets out of our hands. They were a big treat that he got only on the weekends, when we drove down to check on the farm. Prince Charlie would see us drive up and he would trot up from the pasture to the barn like a dog. When we kids saw him out in the field, he would come over and sniff the pockets of our coats to see if we had any Range Pellets. As he got bigger and bigger, his size became a little frightening to us, and when we ran out of the pellets, we would run away. He would follow a few steps, but we always outran him, especially when he was fully grown and too fat to run fast. One weekend when we got to the farm, we noticed that the old wooden door to the tack room had been knocked off. Inside, we found the remains of two hundred-pound sacks of Range Pellets, torn open and devoured. Charlie had gorged himself at leisure and was not feeling so well. He recovered, but he never showed much interest in Range Pellets again. I gradually lost track of Prince Charlie as we both got older, but I know he was never eaten—he was too valuable. I think he spent the rest of his life eating and making babies.

Barbara Radunsky

Barbara Radunsky
Dallas, Texas

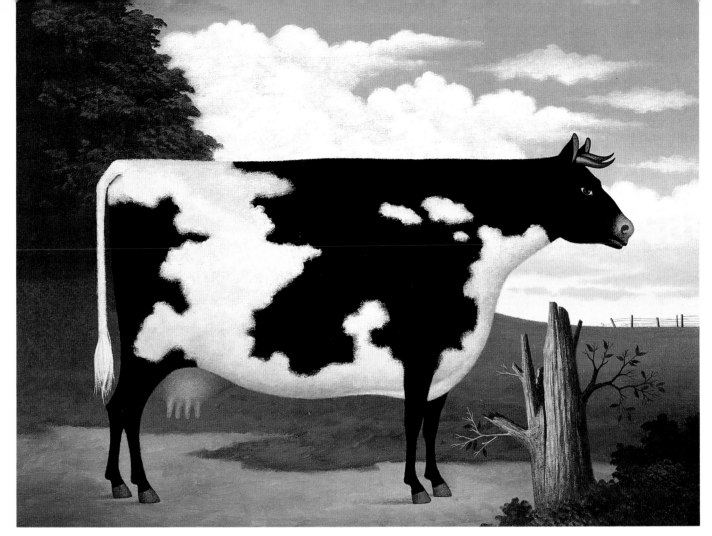

Cow, from an original painting
by Charles Wysocki © 1983
Amcal Inc. Concord, California

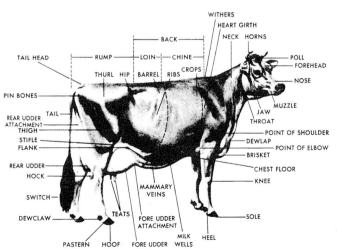

Parts of a dairy cow. (Courtesy, The American Jersey Cattle Club)

WITHERS
HEART GIRTH
NECK HORNS
BACK
POLL
FOREHEAD
RUMP LOIN CHINE
NOSE
TAIL HEAD
CROPS
THURL HIP BARREL RIBS
MUZZLE
PIN BONES
JAW
THROAT
TAIL
REAR UDDER
ATTACHMENT
THIGH
POINT OF SHOULDER
STIFLE
DEWLAP
FLANK
POINT OF ELBOW
BRISKET
REAR UDDER
CHEST FLOOR
HOCK
KNEE
SWITCH
MAMMARY
VEINS
DEWCLAW
TEATS
SOLE
FORE UDDER
ATTACHMENT
PASTERN HOOF
MILK
FORE UDDER WELLS HEEL

(overleaf) *Now Cow*, painting,
1986, by Paul Giovanopoulos,
courtesy Louis Meisel Gallery,
New York City

71

72

73

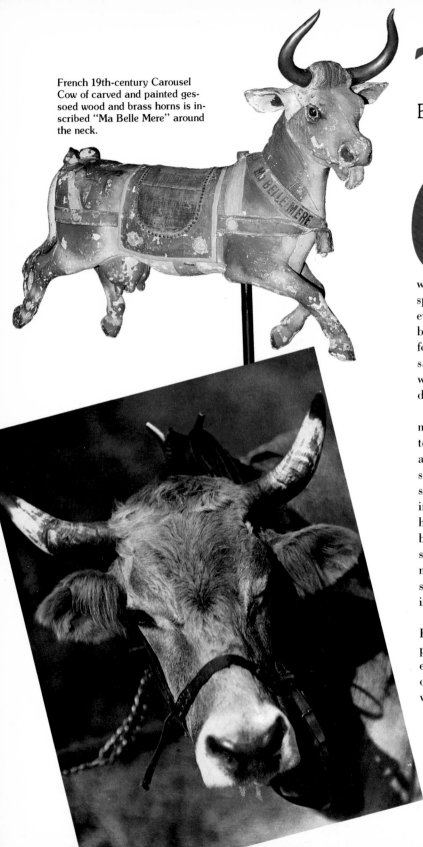

French 19th-century Carousel Cow of carved and painted gessoed wood and brass horns is inscribed "Ma Belle Mere" around the neck.

The Cow
BY PAUL BOWLES

Cow worship is one facet of popular Hinduism which has not yet been totally superseded by twentieth-century faithlessness. True, it has taken on new forms of ritual. Mass cow worship is often practiced now in vast modern concrete stadiums, with prizes being distributed to the owners of the finest bovine specimens, but the religious aspect of the celebration is still evident. The cows are decorated with garlands of jewelry, fed bananas and sugar cane by people who have waited in line for hours to be granted that rare privilege; and when the satiated animals can eat no more they simply lie down or wander about, while hundreds of young girls perform sacred dances in their honor.

In India, where the cow wishes to go she goes. She may be lying in the temple, where she may decide to get up to go and lie instead in the middle of the street. If she is annoyed by the proximity of the traffic streaming past her, she may lumber to her feet again and continue down the street to the railway station, where, should she feel like reclining in front of the ticket window, no one will disturb her. On the highways she seems to know that the drivers of trucks and buses will spot her a mile away and slow down almost to a stop before they get to her, and that therefore she need not move out from under the shade of the particular banyan tree she has chosen for her rest. Her superior position in the world is agreed upon by common consent.

The most satisfying exposition I have seen of the average Hindu's feeling about this exalted beast is a little essay composed by a candidate for a post in one of the public services, entitled simply "The Cow." The fact that it was submitted in order to show the aspirant's mastery of the English language, while touching, is of secondary importance.

The cow is one wonderful animal, also he is quadruped and because he is female he gives milk—but he will do so only when he has got child. He is same like God, sacred to Hindu and

useful to man. But he has got four legs together. Two are forward and two are afterwards.

His whole body can be utilized for use. More so the milk. What it cannot do? Various ghee, butter, cream, curds, whey, kova and the condensed milk and so forth. Also, he is useful to cobbler, watermans and mankind generally.

His motion is slow only. That is because he is of amplitudinous species, and also his other motion is much useful to trees, plants as well as making fires. This is done by making flat cakes in hand and drying in sun.

He is the only animal that extricates his feedings after eating. Then afterwoods he eats by his teeth which are situated in the inside of his mouth. He is incessantly grazing in the meadows.

His only attacking and defending weapons are his horns, especially when he has got child. This is done by bowing his head whereby he causes the weapons to be parallel to ground of earth and instantly proceeds with great velocity forwards.

He has got tail also, but not like other similar animals. It has hairs on the end of the other side. This is done to frighten away the flies which alight on his whole body and chastises him unceasingly, whereupon he gives hit with it.

The palms of his feet are so soft unto the touch so that the grasses he eats would not get crushed. At night he reposes by going down on the ground and then he shuts his eyes like his relative the horse which does not do so. This is the cow.

(from *Their Heads Are Green and Their Hands Are Blue*)

© Skylines

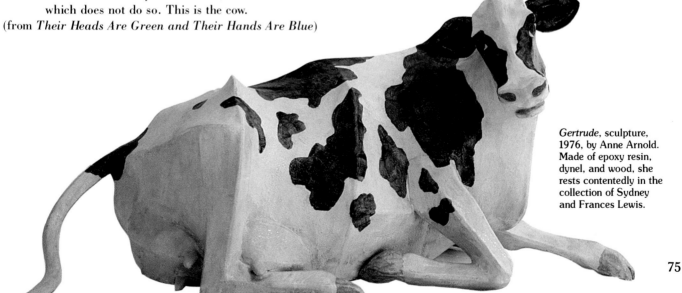

Gertrude, sculpture, 1976, by Anne Arnold. Made of epoxy resin, dynel, and wood, she rests contentedly in the collection of Sydney and Frances Lewis.

75

MOHANDAS K. GANDHI

"The cow is a poem of compassion . . . to protect her is to protect all the dumb creatures of God's creation."

The Sacred Cow of India

Krishna, most celebrated hero of Hindu mythology, rivets the heart of Indians to the cow and all she stands for. Divine shepherd, king-philosopher and pastoral folk-hero, Krishna was an earthly incarnation of the great god Viṣṇu.

As a young boy, Krishna, the foster child of cowherds, showed his divine nature by conquering demons. As a youth, he was the lover of the gopis (milkmaids), playing his flute and dancing with them by moonlight. When the powerful god Indra unleashed a storm, Krishna raised the mountain Govardhana from its base to provide shelter for the village, its people and animals, holding it up with one hand until the danger was over. This feat convinced the people of Krishna's divinity and they henceforth called him the Indra of the Cows.

Surabhi (the cow of abundance) came down from the world of cows (goloka)—also the heaven of the gods—and said to Krishna: "Take the place of Indra for us, oh Master of the world! Ensure the happiness of the cows, of the Brahmins, the gods, and all well-meaning people." Indra himself came to make his apologies and crowned Krishna "King of the Cows."

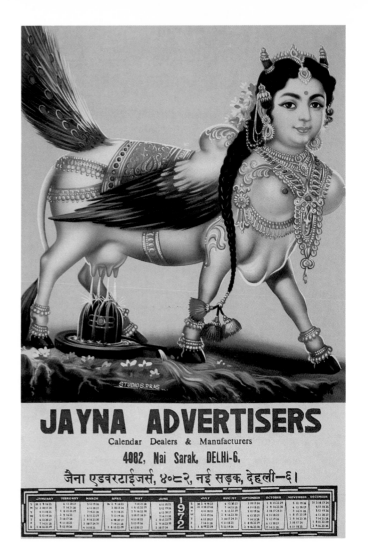

JAYNA ADVERTISERS
Calendar Dealers & Manufacturers
4082, Nai Sarak, DELHI-6.
जैना एडवरटाईजर्स, ४०८२, नई सड़क, देहली—६।

Silver Tiffany cow commemorates the birth of Jessica Mara Berg in New York City.

(opposite, upper right) *Cowpital*, sculpture by Norman Brosterman, epoxy resin cast from an original carving.

76

Cow Myths and Legends

HATHOR, THE EGYPTIAN COW-GODDESS

One of the oldest Egyptian deities, Hathor was depicted and worshipped as a cow, an animal with great fertility significance since prehistoric time. Often shown as a celestial cow whose body was covered with stars, Hathor was honored also as a sky-goddess, a mistress of the stars, and a goddess of love, music, and sacred dance.

THE BIRTH OF THESEUS

Pasiphae, wife of Minos of Crete, was made to fall in love with a bull that Minos had refused to sacrifice. She commissioned her artist/inventor-in-residence Daedalus to carve a wooden cow into which she could slip to consummate her unnatural love (the result was the Minotaur). A fresco of Daedalus presenting the wooden cow to Pasiphae for her approval (perhaps the very first cow sculpture) is in the House of the Vettii in Pompeii.

IO, THE ORIGINAL MOON-WHITE COWGIRL

Io, a young mistress of the Greek god Zeus, was turned into a heifer by the god in order to prevent her discovery by his wife, Hera. Suspicious, Hera had the hundred-eyed Argus guard Io. With the aid of Mercury, who lulled Argus to sleep with his lyre, Io escaped. Chased by a gadfly, she roamed the world, swam the Ionian Sea (named after her), jumped across the strait that separates Europe from Asia Minor (ever since called the Bosporus or "cow ford") and was eventually restored to human form by Zeus. A painting by Peter Paul Rubens shows Mercury about to behead the sleeping Argus while Io the cow draws away in fright.

HERMES AND THE LEGEND OF THE LYRE

When the Greek god Hermes was very young, he went into Apollo's pasture and stole fifty of his best cows. Apollo didn't even notice. Hermes hid the stolen cows, but two of them he sacrificed to the Olympian gods. Then he took the entrails of the sacrificed cows, made seven strings of them, and strung them tautly across an empty tortoise shell. When he plucked the strings, they made lovely music. He had invented the first lyre, precursor to all string instruments. When Apollo realized who had stolen his herd, he confronted Hermes. However, when he heard the music of the lyre he forgot his anger and offered Hermes his whole herd in exchange for the instrument.

PAUL BUNYAN

One of Paul Bunyan's companions in the Red River storybook is Lucy, a giant cow who ate pine trees and gave liniment instead of milk.

THE SILVER COW OF WALES

A young Welsh boy is rewarded for his beautiful harp-playing with a silver cow, the gift of the Tylwyth Teg, the magic people of Wales who live inside the Bearded Lake. The cow makes the boy's family rich, but when his father becomes greedy the Tylwyth Teg exact a stern and poignant revenge. The silver cow and all her offspring are called home to the lake. One by one they plunge into the dark waters and disappear, never to be seen again.

AUDUMULLA, THE SCANDINAVIAN COW

The giant Ymir was the first living being in Scandinavian myth. He was born from the melting ice and suckled by the Cow Audumulla. After he died, his body became land, his blood the sea, his skull the heavens, and his bones the mountains.

NUT AND ISIS

Nut was the Egyptian goddess of the sky, a great cow whose eyes were formed by the sun and moon. Isis, the Egyptian goddess wife of Osiris, held the cow as sacred and was often depicted wearing horns of the cow on her head.

THE DUN COW

The savage beast slain by Guy of Warwick. The fable is that it belonged to a giant, and was kept on Mitchell Fold, Shropshire. Its milk was inexhaustible; but one day an old woman who had filled her pail wanted to fill her sieve also. This so enraged the cow that she broke loose from the fold and wandered to Dunsmore Heath, where she was slain.

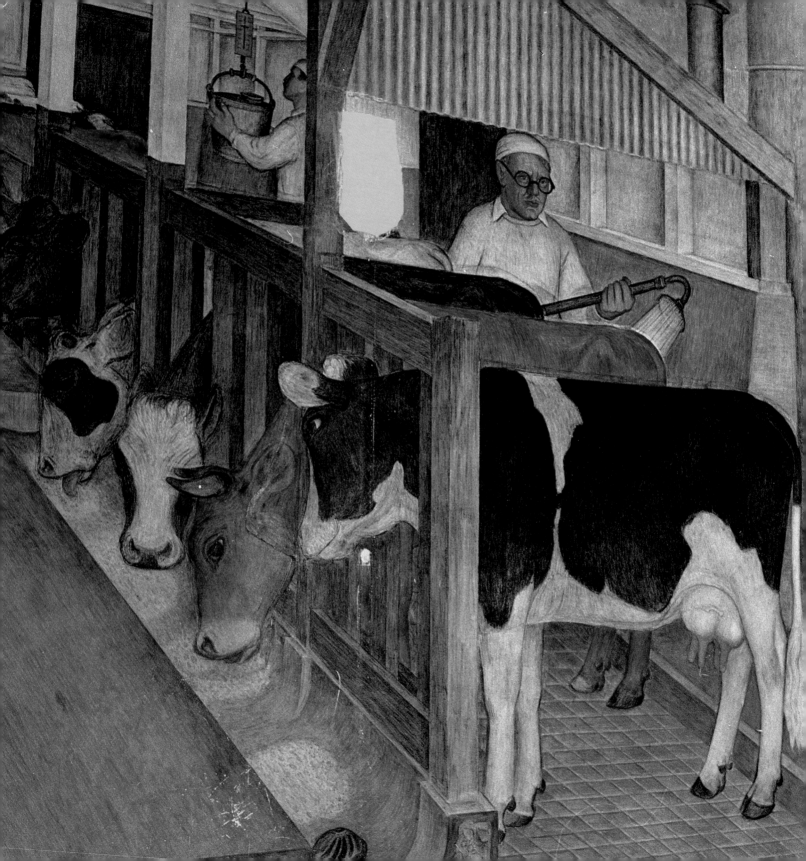

A BIOLOGICAL WONDERMENT

Truly THE COW is the

MOTHER OF PROSPERITY.

Where the cow is kept and cared for, Civilization advances, land grows richer, homes grow better, debts grow fewer.

<div align="right">Hayne.</div>

Cow, the Dumb Mother of Mankind.
<div align="right">Wordsworth.</div>

The Cow—My Dumb Mother.
<div align="right">Leo Tolstoi.</div>

Cow, the foster Mother of Mankind.
<div align="right">Milo Hastings.</div>

Cow—the Mother of ·the Moon.
<div align="right">(Babylonian Mythology)</div>

Mother of *Rudras*, daughter of the *Vasus*, Sister of *Aditya*, Fount of nectar.
<div align="right">(Vedas)</div>

(opposite) The San Francisco Coit Tower mural celebrating the California Agricultural Industry was painted by artist Gordon Langdon as part of the pioneer Federal Arts project begun in 1934. (detail)

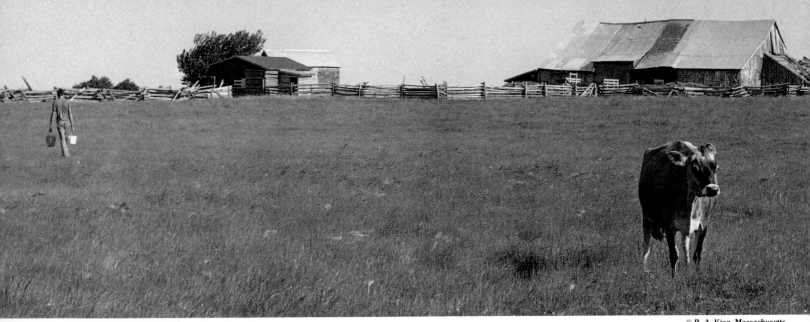

Divine Cows

T he noble simplicity of the natural world around us is often an inspirational source for creativity. Consider the common cow—certainly not conventionally pretty. Yet as an artistic symbol of pastoral peace and plenty she has been making an appearance since time began. Note biblical cows and cubist cows, greeting card cows and collectible cows, a pop Andy Warhol cow and an ultra-feminist Marisol cow (who commemorates a 1976 art exhibit called "Cows" at the Queens [New York] Museum).

Somehow, the essence of cow, with her big, brown, beautiful eyes and soulful gaze, provokes stimulating insights into our own essence. Here, then, are some of the vast, various, and enchanting ways of cow admiration.

Delicate porcelain ceramics by Texas artist Eilene Sky

80

Cows: The Way We Yield

BY SUSAN GRIFFIN

She is a great cow. She stands in the midst of her own soft flesh, her thighs great wide arches, round columns, her hips wide enough for calving, sturdy, rounded, swaying, stupefied mass, a cradle, a waving field of nipples, her udder brushing the grass, a great cow, who thinks nothing, who waits to be milked, year after year, who delivers up calves, who stands ready for the bull, who is faithful, always there, yielding at the same hour, day after day, that warm substance, the milk white of her eye, staring, trusting, sluggish, bucolic, inert, bovine mind dozing and dreaming, who lays open her flesh, like a drone, for the use of the world.

(from *Woman and Nature*)

Boy Milking Cow, painting, 1932, by Grant Wood

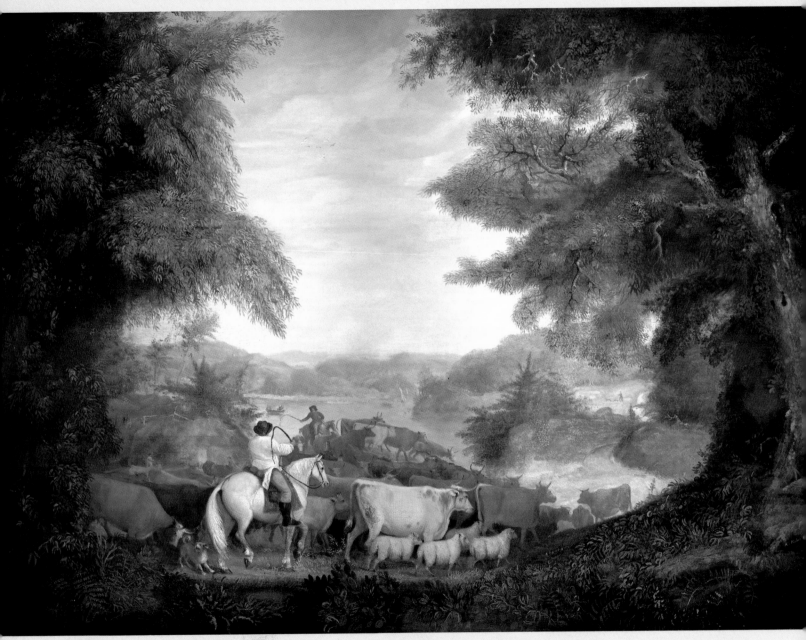

Landscape with Cows, painting by Alvan Fisher. Photograph courtesy
R. H. Love Galleries, Inc., Chicago

The Cow in Western Art

BY MARIO AMAYA

Cows are really not very pretty. They lack the line and elegance of a thoroughbred racehorse, they have none of the exotic appeal of a gazelle or a unicorn and they are not cuddlesome like dogs or cats. And yet the cow has been one of the most pervasive and affectionate animal subjects in the history of art from the time of prehistoric wall scribbles until the present day. . . .

From mythology, the cow slowly emerges in Western art as a symbol of pastoral peace and plenty. The all-giving home-bred animal who asks for little, yet provides milk and meat in copious quantities and is a mainstay of the Western diet, is the very symbol of agrarian cultivation. Farmers driving their herds home in the background of Renaissance paintings personify domestic calm and rural richness. A fine small panel of the early 1500s, depicting the story of Paris, once believed to be by Giorgione (now attributed to Campagnola) shows Paris in an extensive Arcadian landscape, not surrounded with his usual flock of goats, but with a herd of benign cows.

By the mid-17th century, a tradition of landscape painting, particularly in the Low Countries, had firmly established itself and was popular among the bourgeoisie and merchant classes. That cows would be essential to such bucolic scenes was a foregone conclusion. Grazing herds such as those seen in the paintings of Paulus Potter, Jan Van Goyen and Aelbert Cuyp, had a tremendous vogue and at the same time reached a new highpoint in pastoral landscape art. Such Low Country naturalism derived in part from the picturesque landscapes of Claude and Poussin, but had a freshness and vigor which depended on direct observation of familiar scenes rather than obscure references to classical mythology.

In England, Gainsborough and Constable, in direct opposition to French courtly art, carried the tradition of such naturalism even further; the cow was such an integral part of the English landscape that it could not help but be closely associated in art with such pleasant and comfortable, not to mention identifiable, Home County scenes. The rich farming gentry of England reciprocated by designing magnificent parks in which especially bred 'ornamental' cows were left to graze as part of the scenery.

In France the haze of Arcadia lifted from landscape painting in the first half of the 19th century with the Barbizon painters. These artists settled by the edge of the forest of Fontainebleau and set up their easels out of doors to paint exactly what they saw with the common eye. Surrounded by rich farming lands, the Barbizon painters certainly saw lots of cows, along with sheep and geese. The eventual popularity of the Barbizon artists working around Millet and Rousseau in the depths of the country, led to a popular taste for what became known as "cow paintings": views of meadowlands with cows grazing peacefully—a pleasant image in a world becoming increasingly urbanized and in the throes of the industrial revolution and social reform. At a moment when many felt they were losing contact with the land and nature, such art reassured them and comforted them.

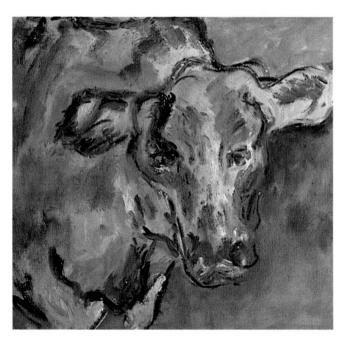

Pink Cow, painting, 1984, by Falvia Bacarella, New York City

Pure landscape painting suddenly became of prime importance to the new French naturalist-realist school and with it came a simple celebration of the farm animal. Courbet, himself, actually went farther than others, painting portraits of prize cows, whereas Daubigny, Diaz and Jules Dupre were content to thread their animals casually through the landscape. It was Constant Troyon who particularly specialized in such animal-filled landscapes and his success was so great that he set up a studio factory in which he painted groups of oxen, cows or sheep and had his assistants fill out the sky and field backgrounds. Artists like Rosa Bonheur were quick to see the success of these subjects and specialized in their own kind of animal paintings.

The idea was quickly picked up in Germany, Italy and America, and the Americans in particular, many of whom were drawn to Barbizon to study, established a naturalist school of landscape painting redolent with farm animals— notably cows. George Inness was a master of this mode and others such as James McDougal Hart, William Hart, Julian Alden Weir, Carleton Wiggins and Winslow Homer, treated the cow with respect in their landscapes. Even Louis Comfort Tiffany, known for his Art Nouveau glass, could not resist depicting his family driving a white cow home through the fields.

By the 20th century, the Cubists had more or less done away with such bucolic subject matter and focused their attention on the man-made or machine-made, rather than unadulterated nature. Only one Cubist work with a cow comes to mind, the painting by Roger de la Fresnaye of 1912– 13 called *Marie Ressort with Her Cows* at The Albright-Knox Art Gallery, Buffalo, New York. Theo van Doesburg's series of pencil drawings of 1917 in which he progressively abstracts a cow is more of an object lesson than any genuine interest in the animal for itself. And curiously, when Roy Lichtenstein parodied van Doesburg some fifty years later, the original cow was mysteriously transformed into a bull. Expressionists such as Franz Marc and Marc Chagall also have used cows in a surreal fashion, but these seem to be exceptions rather than indications of any trend.

It is not until our own day that a new interest in the cow as subject and object has returned notably in Jean Dubuffet's series of cow paintings and drawings done around 1955. Soon after, a number of American artists took up the theme. William Copley in 1957, Alex Katz in 1958, Lois Dodd in 1963, Rauschenberg, and Andy Warhol's cow wallpaper of 1969. Warhol's straight "dumb" approach to the cow conjures

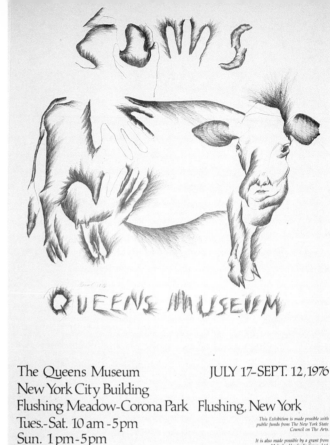

Poster for "Cows" exhibit, painting 1976 by Marisol

up memories from our youth of Elsie the Borden cow who was imprinted on drinking glasses, billboards and milk cartons, and became a national folk heroine. One current approach to the cow is deadpan and factual, without sentimentality, such as in Richard McLean's *Medalion* of 1974 and Bernard Langlais' Wooden Relief of 1971. But with Marisol we see that there is still some wry humor to be wrested from this subject.

This exhibition in no way pretends to be comprehensive. It does attempt to show how the cow has served as symbol and subject for artists throughout the ages. It seems fitting that the cow should be celebrated at the Queens Museum in Flushing Meadow, where she grazed a hundred years ago in peace and tranquility and where Elsie made her sensational debut at the World's Fair of 1939.

(from the exhibition catalog *Cows*, 1976)

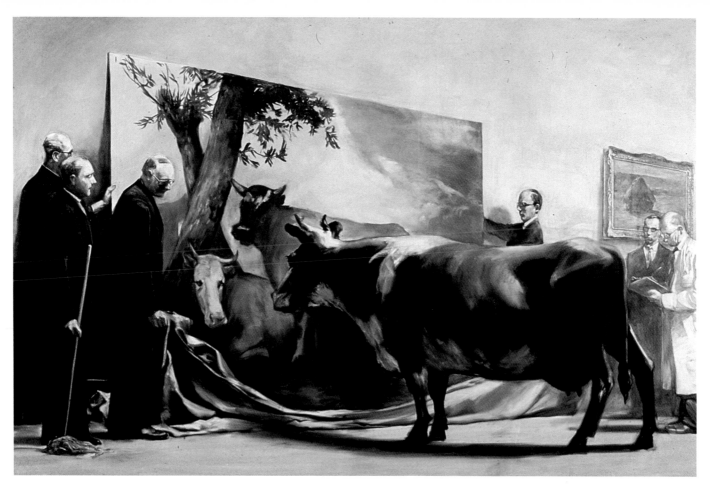

Innocent Eye Test, painting, 1981, by Mark Tansey, New York City

Wire Cow, sculpture by Alexander Calder. Courtesy Museum of Fine Arts, Boston. Gift of Robert Treat Paine II

85

Cow Fans (Boviniacs)

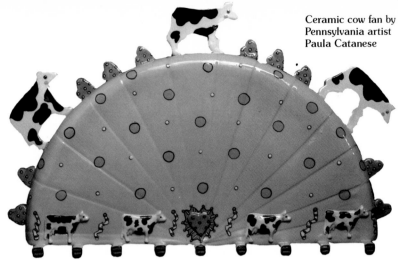

Ceramic cow fan by Pennsylvania artist Paula Catanese

Cows are not exactly elegant, exotic, graceful, or cuddly. They do not make good house pets. Owning one is really out of the question for anyone living even a vaguely urban existence. Yet the simple appeal of this common creature, who has been looked upon for centuries as a tangible symbol of life and fertility, is comforting in our modern hustle-bustle world. The cow inspires passionate affection among lots of people out there, some of whom collect her not in the flesh but in myriad, multiple forms. As cow fans well know, once they've focused in on cowiana the images are everywhere: in primitive folk art and contemporary tee-shirts; on classical Staffordshire pottery and plastic pop earrings; on tin weathervanes, Warhol posters, silver buttons, and paper stamps. Collecting can take you from a farm to a fair to a flea market to a photo exhibit to a fashion show.

What is it that turns an ordinary person into a raving boviniac? (Boviniphile?) Could it be the big, brown, beautiful eyes of the cow? The exotic configuration of her spotted skin? Her meditative, ruminating, communal lifestyle? Her ability to be completely in touch with the earth while nurturing our needs? Or is it that she's an integral part of the great continuum of all that is?

Whatever the cause of the attraction, cow fans are legion. And now at last it's time for cow collectors to celebrate and show off their collections. Call them boviniacs or boviniphiles, they are a breed apart, united by a quirky sensibility that draws them toward the animal in all her statuesque, picturesque aspects. Because to the true cow-lover, the beauty of the beast shines forth in all mixed media.

Mara Kurtz, a New York City native, spent her formative summers at Camp Meadowbrook in Massachusetts, located on the site of a former dairy farm. Across the road was a working farm, and the cows were everywhere. Mara was drawn to cows during this very happy time of her life and has gravitated toward them ever since. Her dream now is to have her own real cow, on a farm upstate, a Holstein she has already named Helen.

Linda Gordon, of New York City and Newport, has loved cows since she was a little girl. During many years of working at the Whitney Museum in New York, and aided by the keen eye of her mother who scouts for cows in England, Linda has amassed an impressive international cow collection, featuring an Italian soup tureen, a Staffordshire cowherd, a silver Indian temple cow, and Andy Warhol's famous cow poster advertising a 1971 art exhibit.

Tom Gallaher, a New Haven architect and city planner, grew up on a farm in Texas. Naturally, cows were everywhere. When he moved east, he was intent on keeping at least the images of cows near him. The centerpiece of his quirky collection is "Murph," a 3 × 5-foot papier-mâché bovine who welcomes all callers to the Gallaher home.

Photograph by Jacques Combe

Jacques Lehmann is an art publisher, dealer in naive and primitive art, and gallery owner in both Paris and New York. He used to collect bilbouquets, and then one day he focused in on a cow and liked the way it looked. *Alors*…here he stands in front of his extensive Parisian cow collection, wearing a beautifully embroidered French denim cow shirt.

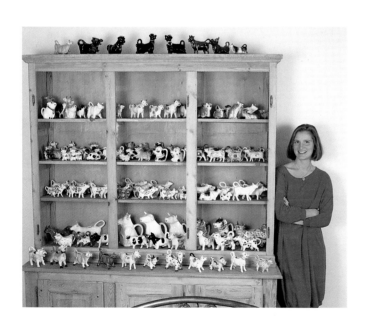

Emily Gwathmey grew up in Manhattan, a bovine-less environment, but became obsessed with the herd of cows she visited daily during summers on Mecox Road in Bridgehampton. Her collection, displayed against the walls of a barn in which cows once resided, includes the poster "Backyard Betsy" by Andrew Williams, cow heads by Ole Kortzau, James McMullan's "Cow," Michael Ansel's "Contented Cow" and Roy Lichtenstein's cow triptych.

Jami Giovanopoulos, a Soho resident and owner of 105 "moo-cow" creamers, was given her first as a wedding present from her godmother A. J. She became fascinated by the astonishing variety of permutations within this simple concept and thus began her collection. She is not alone—apparently Marie Antoinette was also fond of creamers. She is credited with having had the very first one made up in silver many, many years ago.

89

To **Anne Nickinson,** proprietor of the highly popular Amsterdam Avenue restaurant "Good Enough to Eat," cows represent motherhood and all that fills and nurtures. The cow stencils along the outside wall of the eatery are just the first example of the many bovine images to be found within. They serve as the visual theme of this wonderful restaurant, which dishes up food as delicious as mother used to make.

Anthony Morgan, dancer/choreographer, was daydreaming on a bus ride through his native Canada when he noticed some Holsteins grazing in a field. They burned themselves into his mind, seeming to say "choreograph us." Thus the dance "Cows," a whimsical, imaginative piece whereby members of Morgan's company are transformed by bovinelike unitards and painted masks into fanciful facsimiles of the creature he so admires.

"Cows," by Anthony Morgan, Anthony Morgan Dance Company, photograph by John Nalon

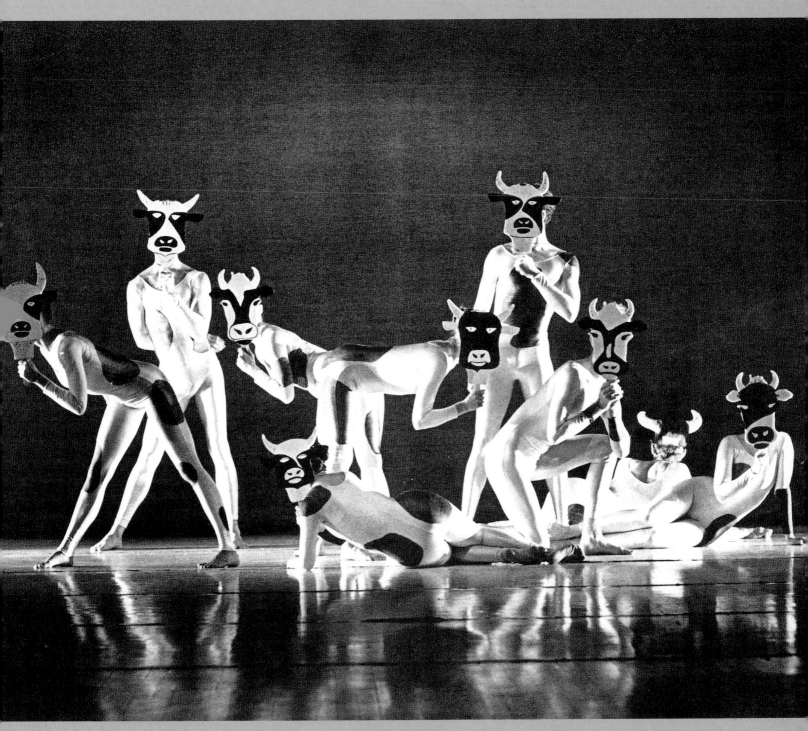

Paul Monroe, jewelry designer and owner of an East Village emporium called *Einsteins*, grew up in New Jersey. The neighbors' cow Betsy grazed near Paul's backyard, and so began his attachment to things bovine, here translated into fetching, funky jewelry.

The Cow Jewels gambol about an antique wooden sewing box

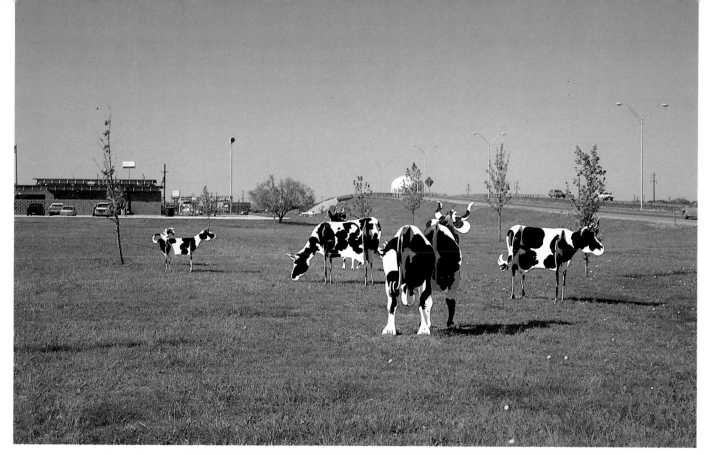

A gathering of Wayne Amerine's
aluminum honeycomb sculptures,
from Dallas, Texas

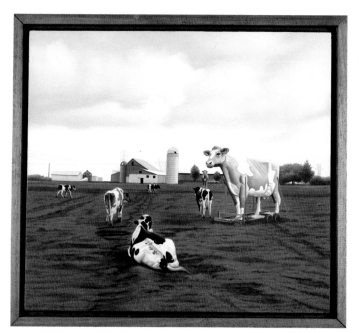

Great American Cow, painting,
1987, by Randall Deihl, courtesy
of Alexander F. Milliken, Inc.,
New York City

An Incomplete Glossary of Cowkind

Bosporus "Cow's Ford"; named for Io, the Greek girl from ancient mythology who was changed into a cow by Zeus.

bovilexia (bo vil eks e uh): the uncontrollable urge to lean out the car window and yell "moo" every time you pass a cow. (© 1984 Sniglets.)

Bovine 1. of, pertaining to, or resembling an ox, cow, or other animal of the genus *Bos*; 2. Sluggish, dull, stolid.

boviniac a person who has excessive enthusiasm for cows.

boviniphile a serious student of cow culture.

chattel synonymous with property, equipment, stock; comes from Middle English and the Old French word *chatel*, which means "cattle."

corniferous horn bearing; producing or having horns.

cow to frighten with threats, intimidate; probably of Scandinavian origin: from the Danish *kue*, to subdue, or the Icelandic *Kuga*, to tyrannize.

cowbane any of several umbelliferous plants supposed to be poisonous to cattle, such as the European water hemlock.

cowbell a bell hung around a cow's neck to indicate her whereabouts.

cow bird any of the American blackbirds of the genus Molothrus (so called because they accompany cattle).

cow boy or girl a person employed in the care of cattle.

cow catcher a triangular frame at the front of a locomotive or streetcar for clearing the track of obstructions, which originally were cows.

cower to bend with knees and back, stand or squat in a bent position; similar to the posture of a cow trying to lie down.

cow hand one employed on a cattle ranch.

cowherd one whose occupation is the tending of cows.

cowhide the hide of a cow, the leather made from it.

cowlick a projecting tuft of hair on the head that will not lie flat (so called because it appears to have been licked by a cow).

cowpoke informal; a cowboy.

cow pony horse used in cattle roundup.

cowpox a contagious skin disease of cattle caused by a virus that is isolated and used to vaccinate humans against smallpox. Also called "vaccinia," of or from cows.

dogie Western U.S. A motherless or stray calf.

impecunious lacking in wealth, or having no cattle.

Ionian Sea named for Io of Greek mythology who was turned into a heifer. A section of the Mediterranean between southern Italy and western Greece.

"Kiss til the cows come home" from *Scornful Lady*, Act III, Scene I, by Beaumont and Fletcher.

low the characteristic sound uttered by cattle—a moo.

maverick 1. an unbranded or orphaned range calf or colt, traditionally considered the property of the first person who brands it; 2. one who refuses to abide by the dictates of his group; an independent. (After Samuel A. Maverick, 1803–1870, a Texas cattleman who did not brand his calves.)

moo to emit the deep, bellowing sound made by a cow; to low.

moola slang for money (origin unknown).

Mrs. O'Leary's Cow reputed to have kicked over a lantern and started the great Chicago fire of 1871.

pecuniary consisting of or pertaining to money (Latin *pecuniarius*, from *pecunia*, "wealth in cattle"). Latin word for money, *pecunia*, from *pecus*, meaning "cattle."

ruminate 1. to chew cud; 2. to meditate at length; muse.

a sacred cow Any institution, long-cherished practice, custom, etc., treated as immune from criticism, modification, or abolition. An allusion to the fact that the cow is held sacred by the Hindus.

DRINKS MADE FROM COW'S MILK
(from Betty Brown's Menu—a Manhattan eatery)

cow juice
milk

purple cow
milk with two shots of grape syrup

black cow
Coca-Cola with vanilla ice cream

brown cow
root beer with chocolate syrup and vanilla ice cream

white cow
vanilla soda with vanilla ice cream

in the hay
strawberry soda with strawberry ice cream

Cow, painting by James McMullan

95

ACKNOWLEDGMENTS

Special thanks to: Walton Rawls for his considerate interest and keen editorial eye; Julie Rauer who patiently took on cow-chaos and returned it to order with her fine design; Annie Gwathmey who taught me about mothering and love; Barbara Strauch, conspiring twin of body and spirit; Rick Landau who patiently anchored a lengthy sojourn among the cows with unflagging love and encouragement; Mimi Chapra, without whose creative dreaming and wide-awake clarity these cows would never have seen the printed page; all the helpful boviniacs and bovineaphiles whose kindly responses inspired and accelerated the cow quest; Diane Cook for aid with picture editing; and a splendid, extended, nurturing, nuclear family.

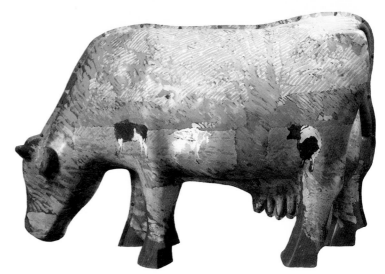

All photographs not otherwise credited are by Niki Berg.

Rubber stamps: (pp. 3, 60, 62, 67) designed by David Alessi, © Rub-A-Dub-Dub Rubber Stamp Works, New York; (pp. 5, 28) designed by Robert Bloomberg, © All Night Media, Inc., San Anselmo, California, used with permission; silver Tiffany cow (p. 76), collection of Jessica Brault; engraving (p. 28) courtesy Cambria Cards, Penmaen Press, Great Barrington, Massachusetts; postage stamps (pp. 94, 95), The Cambridge-Essex Stamp Co., New York City; tin advertising signs (pp. 38, 39) courtesy Roi Davis, Littleton, Colorado; weathervanes (pp. 9, 12), sculpture (14), and sign (30) courtesy Leslie Eisenberg Folk Art Gallery, New York City; rubber stamp (p. 8) courtesy Hero Art, Berkeley, California; Indian calendar (p. 76) collection of Robert and Beverly Katz; photographs (pp. 11, 13, 53, 80) by B. A. King, © Black Ice Publishers, Worcester, Massachusetts; "Milking Shorthorns" sign (p. 39), collection of John Margolies; tin signs (pp. 19, 56), collection of Susan P. Meisel, New York City; rubber stamp images (pp. 4, 38, 75) © Skylines, Biddeford, Maine; painting (p. 85) by Mark Tansey, The Metropolitan Museum of Art, New York, extended loan and promised gift of Charles Cowles, New York City; silver buttons (pp. 80, 82, 83) courtesy Tender Buttons, New York City; photographs (pp. 29, 63) by David Lorenz Winston, © Dancing Light, Merion Station, Pennsylvania; painting (p. 81) by Grant Wood, courtesy Coe College, Cedar Rapids, Iowa, gift of the Eugene C. Eppley Foundation.